DIGITA

DIGITAL PORTRAIT PHOTOGRAPHY 101

Bill Hurter

AMHERST MEDIA, INC. BUFFALO, NY

Published by:
Amherst Media, Inc.
P.O. Box 586
Buffalo, N.Y. 14226
Fax: 716-874-4508
www.AmherstMedia.com

Publisher: Craig Alesse
Senior Editor/Production Manager: Michelle Perkins
Assistant Editor: Barbara A. Lynch-Johnt

ISBN:1-58428-177-4
Library of Congress Card Catalog Number: 2005926593

Printed in Korea.
10 9 8 7 6 5 4 3 2 1

TABLE OF CONTENTS

INTRODUCTION

Good photography comes to those who work at it—and Digital Quick Guides™ are designed to help you improve your photographic skills.

The many techniques contained in this book represent a series of self assignments. Whether you are experimenting with a portrait of a friend, spouse, child, neighbor, or a total stranger, you can take any of the chapters, study them briefly, then go out and try the techniques.

To use this book, it's assumed that you own a digital camera—otherwise you wouldn't have picked it up. Special effort has been made not to make the techniques dependent on expensive equipment. For instance, most of the lighting techniques found in this book are achieved with either available light or a single light source. You will not find techniques that require multiple lights or a studio setup.

You can take any of the chapters, study them briefly, then go out and try the techniques.

The one possible exception to this Adobe Photoshop, which is almost a requirement for the really fun part of digital imaging. Photoshop is not only a helpful program, it's really an essential—especially if you want to become proficient at the many techniques and special effects that can make a portrait really stand out. If Adobe Photoshop is not in your budget, however, you can also achieve excellent results with its bargain-priced brother, Adobe Photoshop Elements.

Included in this book is the work of many top professional photographers from around the world. Their photography is not only technically proficient, but it has an emotional content as well. This second level of communication is the result of instinct, timing, personality, and interaction with the subject. Great photographers take extra measures and it is evident in their work. Hopefully this book and an appreciation for their great work will help propel your photography to that next level.

1. CAMERAS

A good portrait conveys information about the person's "self." Through controlled lighting, posing, and composition, the photographer strives to capture the essence of the subject, all at once recording the personality and the likeness of the subject. The first step in achieving this goal is selecting the right equipment.

■ ADVANTAGES OF DIGITAL

One of the greatest assets of digital capture is the ability to instantly preview images on the camera's LCD screen. If you miss the shot for whatever reason, this means that you can delete that file and redo it right then and there. That kind of insurance is priceless.

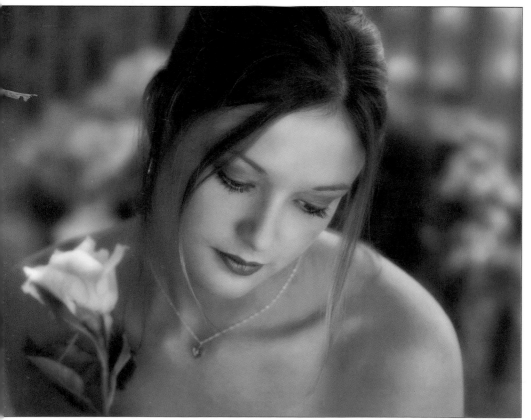

Digital photography allows you to preview your scene on the camera's LCD so that you can verify proper lighting and exposure. This image was created by award-winning photographer Fuzzy Duenkel in all natural light. He used a silvered reflector to bounce light back onto his subject's face. The image was worked on minimally in Photoshop, another great advantage of digital portraiture.

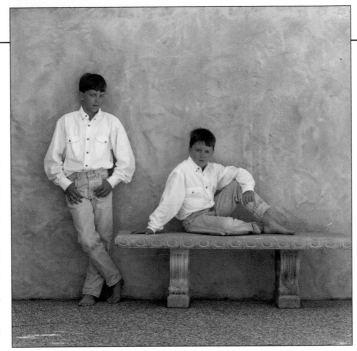

Another great advantage of digital portrait photography is the ability to pre-judge the scene's white balance (the color of the light) and make on the spot adjustments to the color balance of the scene. In this photo by Heidi Mauracher, the late afternoon sun warmed the color temperature of the lighting, making it ideal for portrait photography. Skin tones always look better in warmer light.

For example, imagine you are working outdoors. You examine the first couple of frames and find that the color balance is too cyan because of the color of the shade you are working in. Having noticed the problem immediately, you can just make a quick adjustment to the white balance and be ready to continue shooting. When you review the next frame, though, you find the image is overexposed. You can then adjust your shutter speed, aperture, or exposure-compensation setting to correct it.

With digital, instead of waiting until your lab returns your film to see that you blew it, you can adjust things and move on with the knowledge that your portraits will be flawless.

■ TYPES OF CAMERAS

You can take good portraits with many types of digital cameras. If you prefer a point-and-shoot camera, look for a model with a good zoom lens and the ability to use manual exposure settings. If you are ready to make a bigger commitment to your portrait photography, consider a digital SLR. The prices on these models have dropped dramatically in recent years, and they offer the greatest flexibility—including enhanced exposure and focus controls, interchangeable lenses, and high resolutions. For more on specific camera features and how to use them, read lessons 2 through 8.

2. LENSES

Choosing a lens for portrait photography depends on two factors. First, you'll want to choose a lens that renders your subject without distortion. Second, you'll want a lens that allows you to frame your subject as you like while working at a comfortable distance from the subject.

■ FOCAL LENGTH

The focal length of a lens determines how it renders a subject. From the same working distance, a wide-angle lens will show a broad view (incorporating more of the scene around the portrait subject) while a telephoto lens will give a tighter view (the subject may fill most or all of the frame). When purchasing lenses for digital SLR cameras, you'll find that focal lengths are measured in millimeters, with larger numbers indicating more telephoto lenses. On point-and-shoot models with zoom lenses, the most wide-angle setting is when the lens is retracted; the most telephoto is when the lens is fully extended.

■ SELECTING A SETTING

Normal Focal Length. If you are using a "normal" focal-length lens (about 50mm on an digital SLR or in the middle of the zoom range for most point-and-shoots) you have to move very close to the subject to create a head-and-shoulders portrait. This exaggerates the subject's features—the nose appears elongated and the chin often juts out. When creating full-length portraits, however, you can move farther from your subject and have great success with this focal length.

Joe Photo created this portrait using a telephoto zoom lens and a wide lens aperture to blur the background.

Short Telephoto. Using a short telephoto lens (or zooming in a bit) provides a greater working distance between camera and subject, while increasing the image size to provide normal perspective without subject distortion.

Long Telephoto. You can achieve good results with a longer lens—if you have the working room. A 200mm lens, for

ABOVE—When space permits, the best perspective on your subjects will be achieved by using a short to moderate telephoto lens. Only when cramped for space should you use a wide-angle for group portraits. Photo by Robert and Suzanne Love. RIGHT—Normal lenses are ideal for ¾- and full-length portraits, even of small children. No subject distortion occurs because the camera is farther from the subject. This portrait by David Bentley was made at a fairly wide lens aperture in order to blur the background.

example, is a beautiful portrait lens for digital SLRs because it provides very shallow depth of field and allows the background to fall completely out of focus, providing a backdrop that won't distract from the subject.

Extreme Telephoto. Extreme telephotos (longer than 300mm) should be avoided for two reasons. First, they can cause unflattering distortion. Second, when you use such a lens you have to work far from the subject, making communication next to impossible. You want to be close enough to the subject so that you can converse normally without shouting out posing instructions.

Wide-Angle. When making group shots, you are often forced to use a wide-angle lens. When doing so, keep a close eye on the background and try to avoid including elements that distract from the subjects.

3. APERTURE AND DEPTH OF FIELD

If your camera offers manual exposure settings, there is another lens-based consideration that will have a great impact on your portraits: aperture. The aperture of the lens determines the depth of field of your image—the total range of sharpness in the photo. With small apertures (high f-stop numbers like f/16 or f/32), your subject, the foreground, and the background may all be in focus. With wide apertures (low f-stop numbers like f/2 or f/4), very little other than your subject may be totally sharp.

The trend in contemporary portraiture is to use wide apertures with minimal depth of field. The effect is to produce a thin band of focus, usually at the plane of the eyes. This lets the background fall out of focus and helps keep the viewer's attention on the subject.

■ APERTURE

To select an aperture setting, switch your camera into the manual or aperture-priority mode (consult your camera's manual for how to do this). Most lenses are sharpest when you select an aperture that is one to two f-stops smaller than the widest setting.

In this portrait of a little angel, Chris Becker focused on the eyes. Almost everything else is out of focus. Becker made the image with a Fujifilm FinePix S2 Pro and 80–200mm Nikkor zoom. The exposure was made at 1/60 second at f/3.2 at the 105mm zoom setting.

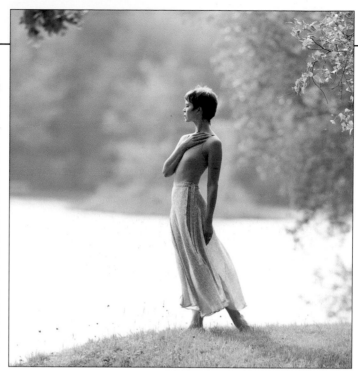

In backlit portraits, it is crucial to avoid underexposure. You can almost count on your in-camera meter reading being wrong. Here, the elegant pose is matched only by the elegant control of the backlighting, which produced detailed shadows and beautiful highlights along the contour of the subject's body. Fine-tuning digital exposures is as simple as reviewing the frame on the camera's LCD and making final adjustments to aperture or shutter speed. Photo by Tony Corbell.

Experiment with a few settings and check your results on the LCD screen (be sure to zoom in to check the fine focus on your subject).

■ ADDITIONAL TIPS

Exposure. The aperture setting also affects exposure. Wide apertures allow lots of light into the camera, so when using them in bright situations you may find that your camera doesn't offer a fast enough shutter speed to compensate and produce an accurate exposure. If this happens, select a smaller aperture or reduce the ISO setting.

Focus. At wide lens apertures where depth of field is reduced, you must remember to focus even more carefully than usual to hold the subject in focus.

Focal Length. Wide-angle lenses have much greater apparent depth of field than telephotos.

Distance to Subject. The closer you are to your subject, the less depth of field you will have. When you are shooting a tight face shot, be sure that you have enough depth of field at your working lens aperture to hold the focus fully on the subject's face.

4. SHUTTER SPEED

Shutter speed, like aperture, is a controlling factor in exposure. While the aperture controls how much light enters the lens, the shutter speed determines how long light will pass through the lens. Like aperture, selecting the shutter speed also gives you some creative control over your image. (*Note:* to select a shutter speed, switch your camera into the manual or shutter-priority mode. Consult your camera's manual for how to do this.)

■ FREEZING THE SUBJECT

For most portraits, you'll want to choose a short shutter speed in order to freeze camera and subject movement and produce the sharpest possible portrait. If you are using a tripod, $\frac{1}{30}$–$\frac{1}{60}$ second should be adequate to stop average subject movement. When working outdoors you should generally choose a shutter speed faster than $\frac{1}{30}$ second, because slight breezes will cause the subject's hair to flutter, producing motion during the exposure.

■ BLURRING THE SUBJECT

Sometimes, you may want to show the motion of your subject—maybe to show them riding a bike or diving into a pool, for instance. In this case, experiment with longer shutter speeds that will allow the motion to render as a blur in the image. Check your results on the LCD to ensure you've achieved the look you want.

■ TIPS FOR SHUTTER SPEED SELECTION

1. If you are not using a tripod, you'll need to use a faster shutter speed to compensate for the fact that you won't be able to hold the camera absolutely motionless. Try $\frac{1}{100}$ second or faster.

IMAGE STABILIZATION LENSES

One of the greatest advancements in modern lens design is the development of the image stabilization lens, which counteracts camera movement, allowing the photographer to handhold the camera and shoot at impossibly slow shutter speeds—such as $\frac{1}{15}$, $\frac{1}{8}$, or $\frac{1}{4}$ second—without encountering any image-degrading camera movement. Such lenses provide the ability to shoot in low light at maximum apertures and still obtain sharp images iwith slow shutter speeds. Currently Nikon, Canon, and Konica/Minolta offer such lenses for their systems.

TOP—Outdoors, where you will encounter breezes from mild to not so mild, shoot at a minimum of $\frac{1}{60}$ second shutter speed. Otherwise, the moving air will blur stray hairs around the subject's face. Photo by Heidi Mauracher. BOTTOM—This image would be impossible without the action-stopping power of a fast shutter speed. Dale Hansen always tries to anticipate the action so that when it happens, his finger is already pressing the shutter. This image was frozen with a $\frac{1}{500}$ second shutter speed.

2. If you are very close to the subject, as you might be when making a tight face shot, you will also need to use a faster shutter speed as any subject or camera movement will be more apparent.

3. When shooting candids or action-type portraits, use a faster shutter speed and a wider lens aperture. With these images, it's usually more important to freeze the subject's movement than it is to have great depth of field.

5. FOCUSING

Generally speaking, the most difficult type of portrait to focus precisely is a head-and-shoulders portrait. It is important that the eyes and frontal features of the face be sharp. It is usually desirable for the ears to be sharp as well (but not always).

At wide lens apertures where depth of field is reduced, you must focus especially carefully to hold the eyes, ears, and tip of the nose in focus. The eyes are a good point to focus on because they are the region of greatest contrast in the face, and thus make focusing simple. This is particularly true for autofocus cameras that often seek areas of contrast on which to focus.

Focusing a three-quarter- or full-length portrait is a little easier because you are farther from the subject, where depth of field is greater.

Remember, after taking a portrait you can always check the focus on the camera's LCD screen. If your camera allows you to zoom in on the image preview, take a close look at the subject's eyes to ensure they are sharp.

ABOVE—Here, the photographer focused slightly behind the profile of the bride and in front of the groom. Depth of field carried the focus. The photographer helped the situation by using a Black Net #2 diffusion filter over the camera lens. This made sharp focus less critical. Photo by Rick Ferro. RIGHT—This is an amazingly sharp portrait. The focusing technique is superb and digital sensors record an image that is even sharper than that rendered on film. If you look carefully you will see how many planes of the subject are aligned in the plane of focus. That's careful subject positioning. Photo by David Williams. FACING PAGE—When focusing a ¾-length portrait such as this, a wide lens aperture can be safely used while keeping all the important parts of the subject in sharp focus. Photo by Fuzzy Duenkel.

6. ISO AND CONTRAST

Higher ISOs produce more digital noise with digital cameras, like fast films, which produce more visible grain the higher the ISO. More grain or noise also means lower contrast. The photographer lessened the contrast even more by using a diffusion filter over the camera lens. Photograph by Robert and Suzanne Love.

■ ISO

The ISO setting controls how sensitive to light the camera's image sensor will be. High ISO settings make the camera more sensitive to light, so you can use smaller apertures and shorter shutter speeds even in lower light conditions.

The lower the ISO setting, the less noise (the digital equivalent of grain) and the more contrast. Shooting at the higher ISOs, like ISO 800 and 1600, produces a lot of digital noise. Many digital image-processing programs contain noise-reduction filters that automatically function to reduce noise levels. New products, such as nik Multimedia's Dfine, a noise reducing plug-in filter for Adobe Photoshop, effectively reduce image noise, post-capture.

BLACK & WHITE MODE

Some digital cameras offer a black & white shooting mode. Most photographers find this mode convenient, since it allows them to switch from color to black & white in an instant. Of course, the conversion can also easily be done later in Photoshop.

Digital ISO settings can be increased or decreased between frames, making digital capture inherently more flexible than shooting with film, where you are locked into a film speed for the duration of the roll.

■ CONTRAST

Contrast is a variable that, on many cameras, you can control at the time of capture when shooting digitally. Most photographers keep this setting on the low side, however. According to award-winning wedding photographer Chris Becker, "Contrast should be set to the lowest possible setting. It's always easy to add contrast later, but more difficult to take it away."

LEFT—Craig Minielly shoots his original images for maximum detail retention. This original image was shot with contrast set to low, all sharpening off, and the exposure set to retain highlight detail. RIGHT—This is the finished version of the shot at left. As you can see contrast has been restored in Photoshop and other effects have been performed using a custom-designed script (called an action), created by the photographer. Image sequence by Craig Minielly, MPA.

7. WHITE BALANCE

On digital cameras, the white-balance settings allow the photographer to correctly balance the color of the image when shooting under a variety of lighting conditions

■ AUTO

Set to automatic white balance, your camera will use it's best judgment to render the colors in the scene as accurately as possible. Often this works very well. For instance, it's a very useful setting if you'll be shooting quickly in a variety of lighting conditions (maybe both indoors and out) and don't want to have to stop to make adjustments to the setting.

■ PRESETS

The preset white-balance settings typically include daylight, tungsten (household light bulbs), and fluorescent. When working where the lighting is consistent, select the setting that best matches the lighting conditions.

Kevin Jairaj says the lighting is not tricky for this shot, but finding good lighting like this is. The image was shot in an outdoor hallway with light coming in from camera right. According to Kevin, "It was really dark in the hallway except for the nice light coming in. I used just a touch of fill-flash to get some sparkle in the eyes." The photo was shot in RAW mode with a Canon 20D and 70–200mm IS L lens at 130mm; exposure was ¹/₂₀ at f/2.8 at ISO 100. The shot is warm-toned because he used a "cloudy" white balance setting to warm the image. He also shoots in RAW mode so he can increase color saturation later.

■ COLOR TEMPERATURE SETTINGS

Some digital cameras also allow the photographer to select white balance settings based on the color temperature of the light (described in Kelvin degrees). These are often related to a time of day. For example, pre-sunrise lighting might call for a white-balance setting of 2000°K and heavy, overcast light might call for a white-balance setting of 8000°K. If you're not familiar with the concept of color temperature, consult any basic photography or lighting manual for a complete discussion.

■ CUSTOM SETTINGS

Many digital cameras also have a provision for creating custom white-balance settings, which is essential in mixed light conditions (say, a room lit by both sunlight and incandescent light).

WALLACE EXPO DISC

An accessory that digital pros swear by is the Wallace Expo Disc (www.expo disc.com). The Expo Disc attaches to your lens like a filter and provides perfect white balance and accurate exposures. The company also makes a Pro model that lets you create a warm white balance at capture. Think of this accessory as a meter for determining accurate white balance, crucial for digital imaging.

To use this feature, simply choose the custom white balance setting, then select a white area in the scene and press the shutter button to create a custom setting. If you do this, you can be assured of a fairly accurate color rendition in your ensuing image captures.

If working in changing light (such as at sunrise or sunset), take another custom white balance reading every twenty minutes or so to ensure that the changing light does not affect the color balance of your scene.

8. EXPOSURE

When making the transition to digital from color negative film, it's important to realize that digital is much less forgiving when it comes to exposure. With color negative film, your exposure could be significantly off and still produce a usable image. With digital, underexposures are still salvageable, but overexposed images (where there is no highlight detail) are all but lost forever. You will never be able to restore highlights that don't exist in the original exposure. For this reason, most digital images are exposed to ensure good detail in the full range of highlights and midtones.

Fortunately, camera manufacturers have built into many cameras two tools to help identify exposure problems. The first is a highlight-overexposure warning. With this active, areas of the image that are extremely overexposed will blink when you review the image on your LCD screen. If you see this blinking, you know you have a problem and need to adjust your camera settings to get a better exposure.

The second way to evaluate the exposure of a digitally captured image is to look at the histogram. This is a graphic representation of the tones in an image file, indicating the number of pixels that exist for each brightness level. The scale of brightness levels range from 0–255, with 0 indicating solid black and 255 indicating pure white.

A perfect exposure was called for at sunset on Lake Tahoe. An overexposure would have blocked up the highlights and changed the contrast of the image, and an underexposure would have limited the shadow detail, which is considerable in this image. Photograph by Robert and Suzanne Love.

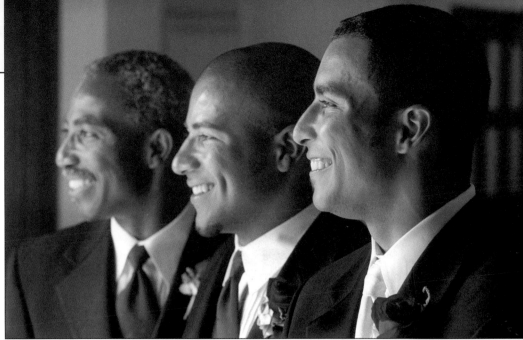

ABOVE—This image was made by working photojournalist, Scott Eklund, a staffer of the *Seattle Post-Intelligencer*. Eklund makes his living by his reflexes and when he encounters a scene such as this, he waits for the moment to define itself. The exposure on this image is perfect. There is strong detail in the highlights and good detail in the shadows. RIGHT— The histogram for the image of the groom and his groomsmen by Scott Eklund shows a good range of tones completely filling the historgram in all three layers. Although the data is predominantly dark-toned, the histogram represents data recorded from steps 1 to 255.

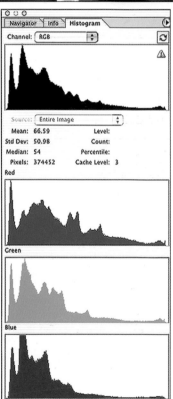

In an image with a good range of tones, the histogram will fill the complete length of the scale. When an exposure has detailed highlights, these will fall in the 235–245 range; when an image has detailed blacks, these will fall in the 15–30 range. The histogram may show detail throughout (from 0–255) but it will trail off on either end of the scale (as the tones approach solid black and pure white).

Histograms are scene-dependent. In other words, the amount of data in the shadows and highlights will directly relate to the subject and how it is illuminated and captured.

9. POSING: SUBJECT COMFORT

The guidelines for subject posing are formalized and steeped in tradition. These rules have been refined over the centuries and have come to be accepted as standard means to render the three-dimensional human form in a two-dimensional medium.

The rules of posing and composition do not, however, need to be followed to the letter; they should simply be understood, because they offer ways to show subjects at their best. Like all rules—especially artistic rules—they are made to be broken. Without innovation, portraiture would be a static, scientific discipline, devoid of emotion and beauty.

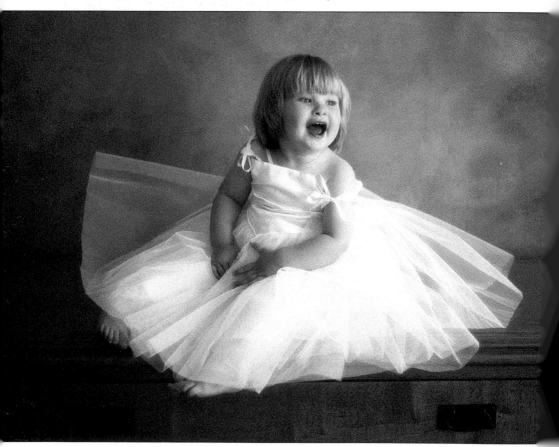

David Williams knows how important it is that his subjects be comfortable before he begins to elicit a good pose. Here, the little ballerina is just plopped down on a dresser, which David often uses as a posing bench for his smaller subjects, and photographed by available light with no fill. He attains this beautiful light simply by opening the front doors to his south-facing in home studio. Williams often plays imaginative games with his child subjects to produce priceless expressions.

Posing is a talent that relies on the basic principle of the subject first being allowed to be comfortable and relaxed for the session. Here, Brian King found a pose that allowed his senior subject to become reflective and thoughtful. If the subject is uncomfortable or worse yet, contorted, you will never reach the level of sophistication attained here.

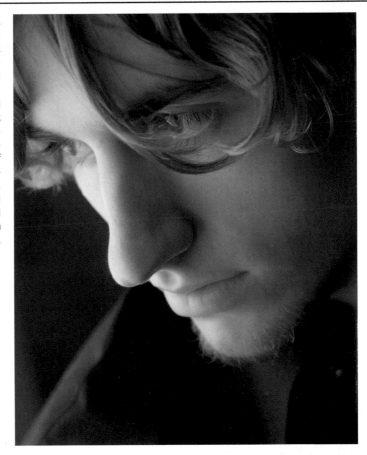

■ SUBJECT COMFORT

The first thing the photographer must do for a subject is to make the person comfortable. For example, posing the subject on a stool or bench is a good way to make them feel comfortable while also ensuring a good, upright posture. But what about outdoors? In this case, find a spot—a patch of grass under a tree or a fence, for example—which will be comfortable for the duration of the shooting session. Pose your subject naturally—a pose that feels good to the subject. If your subjects are to appear natural and relaxed, then the poses they strike must be natural for them.

10. POSING: HEAD AND SHOULDERS

■ HEAD-AND-SHOULDERS AXIS

One of the fundamentals of portraiture is that the subject's shoulders should be turned at an angle to the camera. To have the shoulders facing the camera straight on makes the person look wider than he or she really is. Sometimes, the head is turned a different direction than the shoulders. With men, the head is more often turned the same direction as the shoulders; with women, the head is often at a slightly different and opposing angle.

The subject's arms should not be allowed to fall to their sides, but should project outward to provide gently sloping lines. In the case of a standing man, for instance, you can simply have him put his hands in his pockets to separate his arms from his torso. Posing subjects in this way slims the torso. It also creates a triangular base for the composition. This attracts the viewer's eye upward, toward the subject's face.

Subjects should sit or stand upright but not look rigid.

■ VIEWS OF THE FACE

There are three basic head positions in portraiture:

The Seven-Eighths View. The seven-eighths view is when the subject is looking just slightly away from the camera. In other words, you will see just a little more of one side of the face than the other.

The Three-Quarter View. With a three-quarter view, the far ear is hidden from the camera and more of one side of the face is visible. With this type of pose, the far eye will appear smaller because it is farther away from the cam-

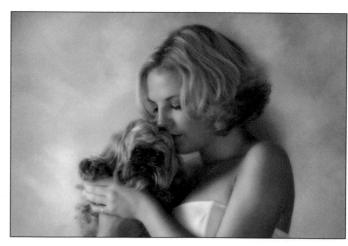

A three-quarters facial view shows much of the face but does not quite reach a profile pose. This beautiful portrait was made by Fuzzy Duenkel.

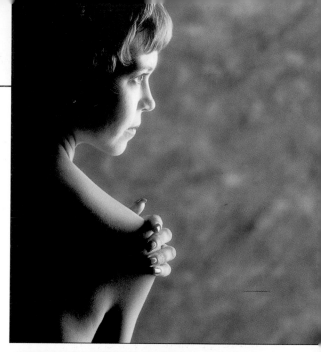

TOP—In the profile pose, the subject is turned away from camera until the far eye and eyelashes disappear. Photograph by Tony Corbell. BOTTOM—To create this window-light portrait, the photographer chose a seven-eighths facial view where the far ear is just out of view. This allows the bride's beautiful face to be revealed in highlight and shadow. Photo by Anthony Cava.

era than the near eye. It is important when posing the subject in a three-quarter view to position him or her so that the smaller eye (people usually have one eye that is slightly smaller than the other) is closest to the camera. This way, the perspective is used to make both eyes appear to be the same size.

The Profile View. In the profile, the head is turned almost 90 degrees to the camera. Only one eye is visible. In posing your subject in a profile position, have him or her turn their head gradually away from the camera position just until the far eye and eyelashes disappear from view.

■ TILTING THE HEAD

Your subject's head should be tilted at a slight angle in every portrait. By doing this, you slant the line of the person's eyes. When the face is not tilted, the implied line of the eyes is straight and parallel to the bottom edge of the photograph, creating a static composition. For a natural look, the tilt of the person's head should be slight and not overly exaggerated.

11. POSING: EYES, MOUTH, AND CHIN

■ THE EYES

It is said that the eyes are the "mirrors of the soul." While that might be a cliché, there is no doubt that the area of primary visual interest in the human face is the eyes.

The best way to keep a subject's eyes active and alive is to engage them in conversation. Try a variety of conversational topics until you find one they warm to and then pursue it. As you gain their interest, you will take their mind off of the portrait session. Another way to enliven the subject's eyes is to tell an amusing story. If they enjoy it, their eyes will smile. This is one of the most endearing expressions a human being can make.

The direction of the person's gaze is all-important. Start the portrait session by having the person look at you. Then, go for a little variety. Looking into the lens for too long a time will bore your subject, as there is no personal contact when looking into a machine.

■ THE MOUTH

Generally, it is a good idea to shoot a variety of portraits, some smiling, some serious (or at least not smiling). People are often self-conscious about their teeth and mouths, but if you see that the subject has an attractive smile, get plenty of shots of it.

Natural Smiles. One of the best ways to produce a natural smile is to praise your subject. Tell him or her how good they look and how much you like a certain feature of theirs. Simply saying "Smile!" will produce that lifeless, "say cheese" type of portrait.

One of the best ways to produce a natural smile is to praise your subject.

Moistening the Lips. Remind the subject to moisten his or her lips periodically. This makes the lips sparkle in the finished portrait, as the moisture produces tiny highlights.

Gap Between the Lips. Some people have a slight gap between their lips when they are relaxed. If you observe this, let them know about it in a friendly way. If they forget, politely say, "Close your mouth, please." When observing the person in repose, this trait is not disconcerting, but when it is frozen in a portrait, this gap between the lips will look unnatural because the teeth show through it.

Laugh Lines. An area of the face where problems occasionally arise is the front-most part of the cheek—the areas on either side of the mouth that wrinkle when a person smiles. These are called furrows or laugh lines. Some people have furrows that look unnaturally deep when they are photographed smiling. If this is the case, avoid a "big smile" type of pose.

■ CHIN HEIGHT

You should be aware of the psychological value put on even subtle facial positions, such as the height of the subject's chin. If the person's chin is too high, he may look haughty—like he has his nose up in the air. If the person's chin is too low, he may look afraid or lacking in confidence.

Beyond the psychological implications, a person's neck will look stretched and elon-

Fuzzy Duenkel created this stunning senior portrait in the girl's family living room. Her smile is pleasant and her chin height is optimum for a confident, relaxed pose. Fuzzy draped her hands out of the way so that all the emphasis is on her face.

gated if the chin is too high. The opposite is true if the chin is held too low; the person may appear to have a double chin or no neck at all.

The solution is, as you might expect, a medium chin height. Be aware of the effects of too high or too low a chin height and you will have achieved a good middle ground. When in doubt, ask the subject if the pose feels natural, this is usually a good indicator of what is natural.

12. POSING: HANDS

Posing the hands properly can be difficult. Throughout this book, though, you'll see great examples of hand posing, pleasing images that render the hands with good dimension and form—but also in a way that seems to reveal the personality of the subject. Take note of them and use them in your images.

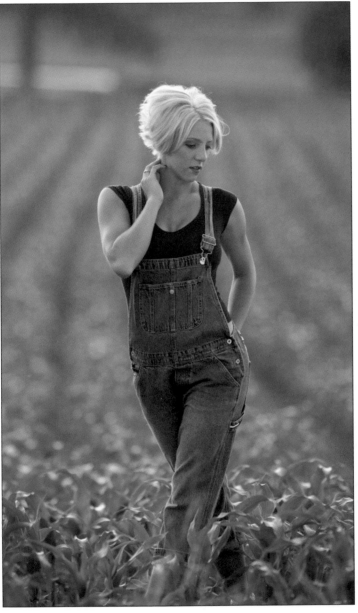

In this senior portrait the photographer posed the hands expertly. The left hand is out of view of the camera, but helps build the triangular base of the composition because it is positioned on her hip, creating a gentle triangle shape. The right hand is curved gently, fingers separated, a slight break at the wrist—a very elegant pose for a young lady. Note: while most people are not flattered by a head-on pose, young girls and children can usually adapt well because they are slim and often small. Photo by Fuzzy Duenkel.

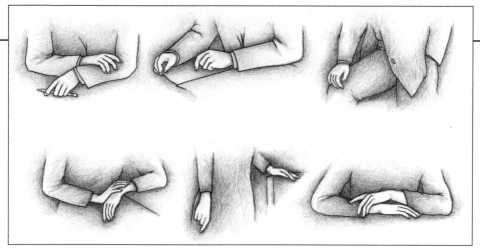

Here are six examples of good hand posing. In each case, the hands are at an angle to the lens. Diagram by Shell Dominica Nigro.

It is impossible to cover every possible pose, so let's make a few generalizations (and keep in mind that these are just that—generalizations, not hard and fast rules):

- Avoid photographing a subject's hands pointing straight into the camera lens. This distorts the size and shape of the hands. Instead, keep the hands at an angle to the lens.
- Photograph the outer edge of the hand whenever possible. This gives a natural, flowing line to the hands and eliminates the distortion that occurs when hands are photographed from the top or head-on.
- Try to "break" the wrist, meaning that you should bend the wrist slightly so there is a gently curving line where the wrist and hand join.
- Try to photograph the fingers with a slight separation in between. This gives the fingers form and definition. When the fingers are closed together, they can appear as a two-dimensional blob.
- When posing women's hands, you should generally strive to create a sense of grace. When photographing men, you will normally look to create an appearance of strength. (Obviously, the type of portrait and the subject must also be considered. For example, the hands of a female soldier in uniform would more logically be posed to convey strength than delicate grace.)

Study the drawings above for suggestions on how to handle portraits in which the hands appear.

13. POSING: FULL-LENGTH PORTRAITS

As you probably understand by now, the more of the human anatomy you include in a portrait, the more problems you encounter. When you photograph a person in a three-quarter- or full-length pose, you have arms, legs, feet, and the total image of the body to contend with.

■ THREE-QUARTER-LENGTH PORTRAITS

A three-quarter-length portrait shows the subject from the head down to a region below the waist. Usually, this type of portrait is best composed by having the bottom of the picture be mid-thigh or mid-calf. Never place the edge of the portrait at a joint, as this can make the limb look strangely cut off.

■ FULL-LENGTH PORTRAITS

A full-length portrait shows the subject from head to toe. Whether the person is standing or sitting, it is important to remember to slant their body (shoulders) to the lens, usually at a 30- to 45-degree angle. Never photograph the person head-on, as this adds mass and weight to the body. The old adage about the camera adding ten pounds is indeed true—and if certain posing guidelines are not followed, you will add a lot more than ten!

For standing poses, have the subject put their weight on their back foot. There should be a slight bend in the front knee if the person is standing. This helps break up the static line of a straight front leg. The back leg can remain straightened; since it is less noticeable than the front leg, it does not produce a negative visual effect. Turn the feet at an angle to the camera; like hands, they tend to look bad when they are photographed head-on.

When the subject is standing, the hands become a real problem. If you are photographing a man, folding the arms across his chest is a good strong pose. Have him lightly grasp his biceps, but not too hard or it will look like he is cold and trying to keep warm. With a standing woman, one hand on a hip and the other at her side is a good standard pose. Don't let the free hand dangle, but rather have her twist the hand so that the outer edge shows to the camera. Always create a bend in the wrist for a more dynamic line.

FACING PAGE—Terry Deglau is a posing master. Starting with the graceful tilt of the head and turn of the shoulders, Terry introduced gentle lines that create a beautiful composition. The subject's weight is on her back foot and a bend in the front knee is evident. Notice how the right hand is elevated upward, the fingers separated and graceful. The eye is drawn upward towards the model's face, the primary center of interest.

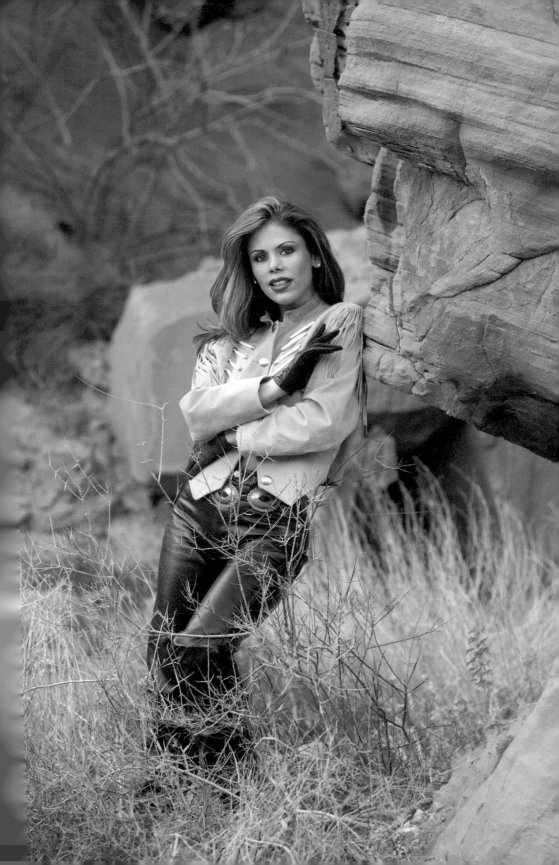

14. COMPOSITION: BASIC RULES

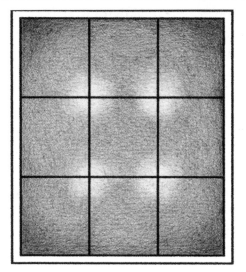

The rule of thirds (left) and the golden mean (right) are two ways of achieving dynamic composi-
tions. In each case, the center of interest, the face or eyes, should be placed on or near an intersec-
tion of two lines within the picture rectangle. Diagrams by Shell Dominica Nigro.

Composition in portraiture is no more than proper subject placement with-
in the frame. There are several schools of thought on proper subject place-
ment, and no one school is the only answer. Several formulas are given here to
help you best determine where to place the subject in the picture area.

■ THE RULE OF THIRDS
Many photographers don't know where to place the subject within the frame.
As a result, they usually opt for putting the person in the center of the picture.
This is the most static type of portrait you can produce.

The easiest way to improve your compositions is to use the rule of thirds.
Examine the diagram above. The rectangular viewing area is cut into nine sep-
arate squares by four lines. Where any two lines intersect is an area of dynam-
ic visual interest. The intersecting points are ideal spots to position your main
point of interest. The main point of interest in your portrait can also be effec-
tively placed anywhere along one of the dividing lines.

In head-and-shoulders portraits, the eyes are the center of interest.
Therefore, it is a good idea if they rest on a dividing line or at an intersection.
In a three-quarter- or full-length portrait, the face is the center of interest.
Thus, the face should be positioned to fall on an intersection or dividing line.

In most vertical portraits, the head or eyes are two-thirds from the bottom of the print. This is also true in most horizontal compositions, unless the subject is seated or reclining. In that case, they may be at the bottom one-third.

■ THE GOLDEN MEAN

A compositional principle similar to the rule of thirds is the golden mean, a concept first expressed by the ancient Greeks. Simply, the golden mean represents the point where the main center of interest should lie and it is an ideal compositional type for portraits. The golden mean is found by drawing a diagonal from one corner of the frame to the other. Then draw a line from one or both of the remaining corners so that it intersects the first line perpendicularly (see the drawing on the facing page). By doing this you can determine the proportions of the golden mean for both horizontal and vertical photographs.

■ DIRECTION

Sometimes, placing the main point of interest on a dividing line or at an intersecting point creates too much space on one side of the subject. Obviously, you would then frame the subject so that he or she is closer to the center of the frame. It is important, however, that the person not be placed dead center.

Regardless of which direction the subject is facing in the photograph, there should be slightly more room in front of the person. This gives the image a sense of visual direction.

David Williams placed the subject forward in the frame, as if he stopped to look back at the camera. Using movement in the frame lends the shot a dynamic quality.

15. COMPOSITION: LINES AND SHAPES

To effectively master the fundamentals of composition, the photographer must be able to recognize real and implied lines within the photograph. A real line is one that is obvious—a horizon, for example. An implied line is one that is not as obvious; the curve of the wrist or the bend of an arm is an implied line.

■ TIPS FOR LINES

1. Real lines should not intersect the photograph in halves. This actually splits the composition in half. It is better to locate real lines at a point one-third into the photograph. This weights the photo more appealingly.
2. Lines, real or implied, that meet the edge of the photograph should lead the eye into the scene and not out of it, and they should lead toward the subject. A good example of this is the country road that is widest in the foreground and narrows to a point where the subject is walking. These lines lead the eye straight to the subject.
3. Implied lines, such as those of the arms and legs of the subject, should not contradict the direction or emphasis of the composition, but should modify it. These lines should present gentle, not dramatic changes in

The shape of the father and son in this portrait forms a pleasing reverse-L shape that nicely blends with the diagonal lines of the rest of the composition. Incorporating pleasing geometric lines and shapes provide heightened visual interest in the portrait. Note that subject placement is in concert with the rule of thirds placement. Photograph by Fran Reisner.

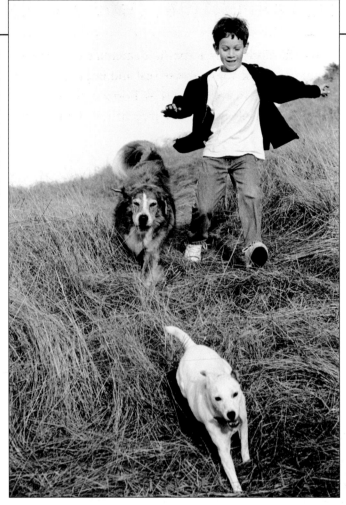

A beautiful S curve is formed by the line of the dogs and the boy and the hillside. Sometimes this is luck, but certainly being aware of and prepared for such compositions will increase your chances of capturing a moment like this. Photography by Janet Baker Richardson.

direction, and again, they should lead to the main point of interest—either the eyes or the face.

■ COMPOSITIONAL FORMS

The S-shaped composition is perhaps the most pleasing of all compositions. The gently sloping S shape is used to lead the viewer's eye to the point of main interest, which should still be placed according to the rule of thirds or the golden mean.

Another pleasing type of composition is the L shape or inverted L shape. This type of composition is ideal for reclining or seated subjects. Again, the center of interest should still be placed according to the rule of thirds or the golden mean.

16. COMPOSITION: TONE AND FOCUS

■ SUBJECT TONE

The rule of thumb is that light tones advance visually, while dark tones recede. It is a natural visual phenomenon.

Therefore, elements in the picture that are lighter in tone than the subject will be distracting. Of course, there are portraits where the subject is the darkest part of the scene, such as a subject dressed in white against a white background. This is really the same principle at work as above, because the eye will go to the region of greatest contrast in a field of white or on a light-colored background.

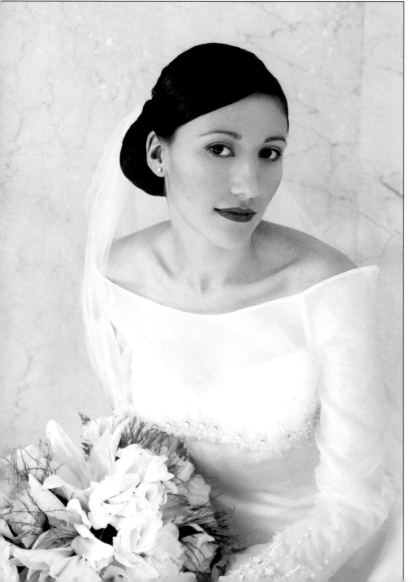

Marcus Bell chose to photograph this bride against white marble, seeing that he was creating a predominantly light-toned (high-key) portrait. The area of greatest contrast and visual interest is her eyes, which are beautiful and the intended center of interest. This image was made by available light in the hotel lobby where the reception was taking place.

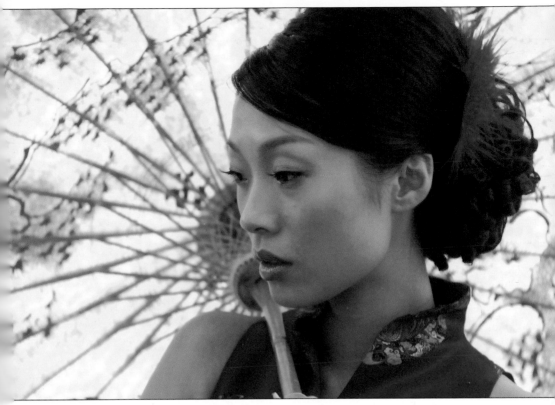

A radial pattern of the parasol dominates this portrait by Joe Photo. A strong diagonal line moving from upper right to lower left and following the line of the subject's eyes is the key design element and the aspect that makes this image have impact. Notice that the focus is on the bridge of her nose so that both eyes are sharp.

The guiding principle is that, regardless of whether the subject is light or dark, it should visually dominate the rest of the photograph either by brightness or by contrast.

■ FOCUS

Whether an area is in focus or out of focus has a lot to do with the amount of visual emphasis it will receive.

For instance, imagine a portrait in which a subject is framed in green foliage, yet part of the sky is visible in the scene. In such a case, the eye would ordinarily go to the sky first. However, if the sky is soft and out of focus, the eye will revert back to the area of greatest contrast—hopefully the face.

The same is true of foreground areas. Although it is a good idea to make them darker than your subject, sometimes you can't. If the foreground is out of focus, however, it will detract less from a sharp subject.

17. PORTRAIT LIGHTING BASICS

A photograph is a two-dimensional representation of three-dimensional reality, thus the aim of the photographer is to produce a portrait that shows roundness and form of the human face. This is done primarily with highlights (areas that are illuminated by the light source) and shadows (areas that are not). Just as a sculptor models clay to create the illusion of depth, so light models the shape of the face to give it depth and form.

The shape of the subject's face usually determines the best lighting pattern to use. You can widen a narrow face, narrow a wide face, hide poor skin, and disguise unflattering facial features (such as a large nose) all by thoughtful placement of your key light.

■ TYPES OF LIGHT

Almost any kind of light can be used to create a great portrait. Many portraits are created outdoors using sunlight. Others are created indoors using household lamps, on-camera flash, or other light sources—you can even light a portrait by candlelight.

In short lighting setups, the main light is used to light the side of the face turned away from the camera. Shadows fall where the light does not strike the face directly. Photograph by David Williams.

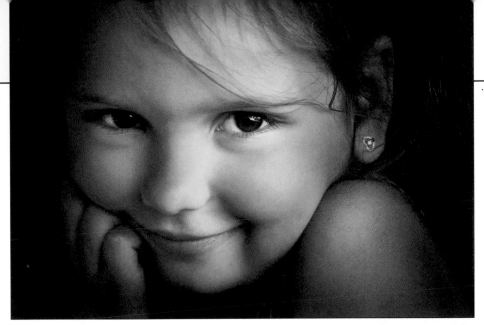

In broad-lighting situations, the side of the face most visible to the camera is illuminated. In this portrait by Frank Cava, made by window light, the large highlight on the girl's cheek was subdued in Photoshop. Both the ear and shoulder would also have been well lit, but to focus attention on her face, Frank darkened these areas.

■ ONE MAIN LIGHT

A Single Source. Whatever kind of light you choose, the subject should appear to be lit by just one light source. This mimics the light we are most used to seeing on people: sunlight. This doesn't mean that only one light source can be used, just that one source must be primary. Other sources can be used, but they should be less bright than the main light and should not cause cross shadows (shadows that extend in different directions).

Direction. It is important that the main light never dip below the subject's head height. In traditional portraiture this is avoided because it does not occur in nature, where light from the sun always comes from above the horizon. Light that comes from below the subject can, however, be used if you want to create a ghoulish or spooky portrait.

■ BROAD AND SHORT LIGHTING

There are two basic types of portrait lighting: broad lighting and short lighting. In broad lighting, the main light source illuminates the side of the face turned toward the camera. It is often used to widen a thin or long face. In short lighting, the main light source illuminates the side of the face turned away from the camera. This emphasizes facial contours, and can be used as a corrective lighting technique to narrow a round or wide face.

39

18. OUTDOOR LIGHT: WHAT TO LOOK FOR

The great diversity of outdoor lighting makes it ideal for learning about portrait lighting. By far the best place to make outdoor portraits is in the shade, away from direct sunlight. There are ways to utilize direct sun in portraits, as will be shown, but first one needs to learn to see lighting in the shade.

■ SHADE

Shade is nothing more than diffused sunlight. The best shade for portraiture is found in or near a clearing in the woods. In such areas, where trees provide an overhang above the subject, the light is blocked from above and light filters in from the side. This produces better modeling on the face than light from the open sky, which is overhead in nature and unflattering because it leaves shadows in the eye sockets and under the nose and chin of the subject.

■ DIRECT SUNLIGHT

While shade is the best outdoor light for making portraits, successful images can also be created in direct sunlight. The two main problems with direct sunlight are the harshness (contrast) of the light and the subject's expression as a result of this harshness. If the person is looking toward a bright area, he or she will naturally squint—a very unnatural expression at best.

Skimming the Light. To control the harshness of the light, position your subject so that the light skims the person's face rather than striking it head-on. This will bring out the roundness in the face, reducing the pasty skin tones

Backlighting blocks direct sunlight from striking the subjects faces. In this lovely portrait, Melanie Nashan used a simple white reflector to bounce light back onto the subjects.

often associated with portraits made in direct sun.

Cross Lighting. When the sun is low in the sky, you can achieve good cross lighting, with the light coming from the side of the subject so almost half of the face is in shadow while the other half is highlighted. With the sun at a low angle, the subject will not squint, particularly if looking away from the sun. Position the subject's head so that the side lighting does not hollow out the eye socket on the highlight side of the face.

Backlighting. Backlighting is another very good type of direct sun lighting. The sub-

You can make beautiful images even in direct sunlight, provided you fill in the shadows. Here, on-camera flash helped lessen the overall contrast of the light and filled in the shadows. Photo by Kimarie Richardson.

ject is backlit when the sun is behind the person, illuminating their hair and the line of their neck and shoulders. With backlighting, it is essential to use supplemental light on the subject's face. This can be done using fill flash (a reduced-power flash setting available on many cameras or with auxiliary flash units) or a reflector.

If you've never used a reflector, this is a good time to give one a try. Just get a piece of white foam-core board and have an assistant hold it in front of the subject. Place it as close as possible to the subject without being in view of the camera lens and angle it upward into the subject's face. (*Note:* Collapsible round reflectors are also available for purchase at most camera stores and are easy to use and store.)

Don't trust your in-camera meter in backlit situations. It will read the bright background and highlights on the hair instead of the exposure on the face. For the best results, move in close and take a reading on the subject's face, being careful not to block the light from the reflector.

19. OUTDOOR LIGHT: MODIFYING

■ ELIMINATING OVERHEAD LIGHT

If you find a nice location for your portrait but the light is too overhead in nature, creating dark eye sockets and unpleasant shadows under the nose and chin, you can create a light-blocker to reduce the overhead illumination. You can try using a piece of foam-core board or even a white sheet directly over the subject's head (of course, you'll need to enlist some volunteers to assist you with this!). The light that strikes the subject from either side will then become the dominant light source. Keep in mind that this will lower the over-all light level, so you may have to shoot at a slower shutter speed or wider lens aperture than anticipated.

■ SCRIMS

If you find an ideal location, but the light filtering through trees is a mixture of direct and diffused light (i.e., spotty light), you can use a scrim held

In this portrait by Kevn Jairaj, soft late afternoon backlighted the baby. A silver reflector, layed in the grass close to the baby, kicks up the beautiful soft light, which fills in all the shadows.

Shade with an overhang above, such as the roof of this building, creates beautiful lighting with good modeling and dimension. The diffused daylight is blocked from above, allowing light to filter in from the side. Photo by Tony Corbell.

between the subject and the light source to provide directional but diffused lighting.

Scrims, sometimes called diffusion flats, are made of translucent material on a semi-rigid frame. For those who are serious about their outdoor photography, scrims can be purchased. Crafty photographers can make their own using any semi-transparent material supported on a wooden or metal frame— or it can even be held by a couple of willing assistants.

These are great when you want to photograph your subject in direct sunlight. Simply position the scrim between the light source and the subject to soften and change the available lighting. The closer the scrim is to the subject, the softer the light will be on the subject. (This type of diffusion works best with head-and-shoulders portraits since the size of the scrim can be much smaller and it can be held much closer to the subject.)

The scrim will lower the amount of light on the subject and, as a result, the background may be somewhat overexposed—but this is not necessarily an unflattering effect. To avoid the background completely washing out, choose a location with a dark- to mid-colored background, so the effect will not be as noticeable.

■ A SOLID COLOR

The best type of background for a portrait made in the shade is one that is monochromatic. If the background is all the same color, the subject will stand out from it.

■ PATCHY BACKGROUNDS

Problems arise when there are patches of sunlight in the background. These can be minimized by shooting at wide lens apertures. The shallow depth of field blurs the background so that light and dark tones merge. You can also use a soft-focus filter over the lens to give your portrait a misty feeling and minimize a distracting background.

■ OVEREXPOSURE

The light that falls on a scene in the distance may be quite different than the light on your subject—especially if your subject is posed in the shade where the light levels will be much lower than in the full-sun area beyond the shade's edge. This is not always a problem, but it's something to keep an eye on. Selecting an area with a naturally dark back-

Stacy Bratton photographed these two sisters in spotty light. She raised the camera angle to minimize much of the background in the composition and she exposed for the girls' faces, allowing the background highlights that did show to overexpose. Stacy turned a deficit into a plus by carefully working with the background.

Joe Photo chose a gorgeous background for this bridal portrait—a seemingly endless tunnel of trees at an estate in France. He placed the bride in shade, while the majority of the background was in late afternoon sun and used a wide aperture so the background would be out of focus. In Photoshop, he later vignetted the image (darkened the corners) to complete the effect.

ground (such as dark green foliage) can minimize the problem.

■ CREATE SEPARATION

One thing you must be aware of outdoors is subject separation from the background. A dark-haired subject against a dark background will not tonally separate, so the subject will seem to blend into the background. To solve the problem, look for a lighter background or find a way to reflect light onto the hair so that it separates from the background (sometimes a reflector placed in close to the subject's face will do the job).

■ RETOUCHING

If all else fails, you can minimize the impact of a distracting background using digital retouching. When working with a digital image, the burn tool in Photoshop (and other image-editing programs) can be used to selectively darken the background without affecting the exposure on the subject.

21. OUTDOOR LIGHT: ADDITIONAL TIPS

■ USE CARE IN SUBJECT POSITIONING

Natural-looking subject positioning is often a problem when on outdoor location. If possible, a fence makes a good support for the subject. If you have to pose the subject on the ground, be sure it is not wet or dirty. Bring along a small blanket, which, when folded, can be hidden under the subject. It will ease the discomfort and also keep the subject clean.

■ EMPLOY A TRIPOD

You should use a tripod when shooting outdoor portraits. Shutter speeds will generally be on the slow side, especially when you are shooting in shade. Also, using a tripod helps you compose your portrait more carefully and gives you the freedom to walk around the scene and adjust things as well as to converse freely with your subject. A tripod is also a handy device for positioning a reflector (the collapsible round ones often come with loops that can be attached to the control knobs of the tripod).

■ FIX IT IN PHOTOSHOP

Sometimes you may choose a beautiful location for a portrait, but find that the background is totally unworkable. It may be a bald sky or a cluttered background. The best way to handle such backgrounds is in Photoshop. Using this software, you can

Careful and comfortable positioning of the subjects on the side of a sand dune help photographer Robert Love create identical portraits of identical twins. Love wanted the girls' hair to do exactly the same thing, and as long as they were posed comfortably, he could take the time to get the details right. Notice that where the overexposed blond hair merges with the background, the photographer burned down the sand so that it would be darker than the hair.

Late in the day is about the only time you can use open shade for effective portrait light. Marcus Bell used a bit of flash fill to add catchlights in the girl's eyes. The final step was to add a vignette.

vignette the image to de-emphasize the background (see lesson 41). You can also selectively diffuse the background (without sacrificing the critical focus on the subject). See lesson 33 for tips on doing this.

■ WATCH THE COLOR IN THE SHADOWS

Another problem you may encounter is excess cool coloration in portraits taken in shade. If your subject is standing in a grove of trees surrounded by green foliage, there is a good chance that green will be reflected into the subject's face. If the subject is exposed to clear, blue, open sky, there may be an excess of blue in the skin tones. This won't affect your black & white shots, but when working in color, you should beware.

In order to correct green or cyan coloration, you must first observe it. Although your eyes will quickly neutralize the color cast, the digital media will not be as forgiving. Study the subject's face carefully and especially note the coloration of the shadow areas of the face. If the color of the light is neutral, you will see gray in the shadows. If not, you will see either green or cyan. This can be eliminated after the shoot in Photoshop, or you can try adjusting your camera's white balance to warm up the image (make it slightly more pink).

47

22. WINDOW LIGHT: THE BASICS

This image by Brian Shindle was lit by a bank of windows roughly 10 feet from the little girl. A single reflector was used on the shadow side of the girl for fill-in.

■ QUALITIES OF WINDOW LIGHT

Advantages. One of the most flattering types of lighting you can use in portraiture is window lighting. It is a soft light that minimizes facial imperfections, yet it is also directional with good shaping qualities. Window light is usually a fairly bright light source that will allow you to handhold the camera if a moderately fast ISO and wide aperture are used. Window light is infinitely variable, changing almost by the minute, allowing a great variety of moods in a single shooting session.

Drawbacks. Window lighting has several large drawbacks as well. Since daylight is much weaker several feet from the window than it is close to the window, great care must be taken in determining exposure. If the subject moves, even as little as six to eight inches, the exposure will change. Another drawback is that you cannot move the light source, so you must move your subject in relation to the window. This can sometimes set up odd poses. You will sometimes have to work with distracting backgrounds and at uncomfortably close shooting distances.

■ TIME OF DAY

The best quality of window light is found in the soft light of mid-morning or mid-afternoon. Direct sunlight is difficult to work with because of its intensi-

ty and because it will often create shadows of the individual window panes on the subject. It is often said that north light is the best light for window-lit portraits. This is not necessarily true. Good quality light can be had from a window facing any direction, provided the light is soft.

■ SUBJECT POSITIONING

One of the most difficult aspects of shooting window light portraits is positioning your subject so that there is good facial modeling (shaping). If the subject is placed parallel to the window, you will get shadows that can be harsh. It is best to position your subject three to five feet from the window and have them look back toward the window at an angle. This not only gives good, soft lighting on most of the face, but also gives you a little extra room to produce a flattering pose and pleasing composition.

Window light is soft but directional. The farther your subject is from the window, the less intense the light gets and the more contrasty it gets. Here, the mother and child are close to the soft window light and in Photoshop, additional softness was added, thus lowering the contrast and increasing the softness of the image. Note that the mother has less exposure than the child, who is closer to the window. Photograph by Jennifer George Walker.

49

LEFT—This beautiful window-lit portrait uses multiple light sources. The window light is cool and daylight balanced, but the shadow fill is a mixture of window light and room lights, hence the warm tones in the shadows. A conscious decision must be made as to where to bias the light, in this case towards the daylight white balance, allowing the shadows to be warm. Photograph by Judy Host. RIGHT—Brian King positioned his subject facing the window and had her look back toward the camera, using the shape of her face to block the soft light.

■ EXPOSURE

To meter accurately for a good exposure, move in close to the subject and take a reading off the face. If the subject is particularly dark-skinned, open up at least one f-stop from the indicated reading. Most camera light meters take an average reading, so if you move in close on a person with an average skin tone, the meter will read the face, hair, and what little clothing and background it can see and give you a fairly good exposure reading.

If using an average ISO (ISO 200), you should be able to make a hand-held exposure at a shutter speed like ¹/₃₀ second with the lens opened up to f/2.8. Of course, this depends on the time of day and intensity of the light, but in most cases handheld exposures should be possible. Since you will be using the lens at or near its widest aperture, it is important to focus carefully on the subject's eyes (in a full-face or seven-eighths pose) or the bridge of the nose (in a three-quarter view). Depth of field is minimal at these apertures, so control the pose and focus carefully for maximum sharpness on the face.

■ WHITE BALANCE

A custom white-balance reading should be taken, since most window-light sit-uations will be mixed light (daylight and room light). If working in changing light, take another custom white balance reading every twenty minutes or so to ensure that the changing light does not affect the color balance of your scene.

White balance cor-rections can com-pletely alter the way an image is cap-tured. By intention-ally selecting a white balance set to shade when the lighting is tungsten-balanced gives the image an uncharac-teristic warm look. Photograph by Anthony Cava.

24. WINDOW LIGHT: MODIFYING

Sometimes in a home, you will encounter floor-to-ceiling windows with sheer curtains underneath thicker drapes. These sheers act like a scrim, diffusing the incoming window light. Here, Deanna Urs used such a setup to light this lovely young girl. The light, coming in from camera left, provides a beautiful soft lighting pattern. The girl's hat, which is also translucent, blocks some of the light coming from above, but not enough to adversely affect the lighting.

■ ADD A REFLECTOR

One of the biggest problems commonly encountered with window light is that there is not enough light to illuminate the shadow side of the subject's face. The easiest way to brighten the shadows is with a large reflector placed next to the subject on the side opposite the window. The reflector has to be angled properly to direct the light back into the face.

■ ADD ROOM LIGHTS

If you are shooting a three-quarter- or full-length portrait, a reflector may not be sufficient; you may need to provide another source of illumination to achieve a good balance. Sometimes, if you flick on a few room lights, you will get good overall light. Just be sure the room lights do not overpower the window light, otherwise, you will encounter a strange lighting pattern with an unnatural double-shadow effect.

When using daylight white-balance setting, you will get a warm glow from the room lights. This is not objectionable as long as the light is diffused and not too intense.

It is also a good idea to have a room light in the background behind the subject. This opens up an otherwise dark background and provides better depth in the portrait. If possible, position the background room light behind

the subject or off to the side, out of the camera's field of view. A bright light, if seen behind the subject, can be distracting.

■ SOFTEN THE LIGHT

Occasionally, you'll find a nice location for a portrait but discover that the light coming through the windows is direct sunlight. When this occurs, you can diffuse the window light.

Diffusion flats for this purpose are sold commercially in sizes up to eight feet long, but you can also make your own by attaching any kind of diffusion material (like frosted shower-curtain material) to a light-weight frame.

Lean the flat in the window (or use masking tape to hold it in place) at a height that diffuses the light falling on your subject. Remember, the larger the diffuser, the larger and more diffused your light source will be.

You can also use the scrim to diffuse sunlight coming through a window for a golden, elegant window light. Light diffused in this manner has the warm feeling of sunlight but without the harsh shadows.

Dennis Orchard created a beautiful mix of daylight and room light. By white-balance correcting for the window light, he was able to color balance the light on the mask of this lovely bride's face. The room lights produce warm-toned shadows, making the photograph feel natural and blend well with the window light. The trick is to balance the intensity of the mixed lighting so that one source does not overpower the other.

25. CANDID SHOTS: TECHNICAL CONCERNS

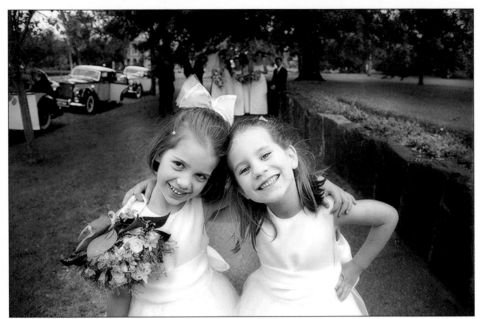

As the bridal party approached (background) these two flower girls were the advance scouts. David Williams chose to let them ham it up in front of the camera for a wonderful slice of the day.

Some of the finest portraits are those made without the subject being aware of the camera. In such images, the objective is to let the scene tell the story, recording a delicate slice of life. Keep in mind that, while the portraits may be spontaneous, the basic aesthetic aspects of lighting, composition, and posing should not be discarded.

■ COMPOSITION

You are depending on the action to give you the impact of the photograph. Therefore, you should compose the scene loosely so that it may be cropped later for better composition. Leave plenty of space around the subject(s) and concentrate on the scene and the action itself.

■ SHUTTER SPEED

To work unobserved, you'll need to avoid using flash even in low light situations. Instead, pick a higher ISO setting and longer shutter speed. At slow shutter speeds, though, steady camera handling is all-important. To help, keep your elbows in close to your body when the camera is held up to your eye.

Position the thumb of your right hand on the camera base-plate so that it acts as a counter-support for your index finger, which depresses the shutter button. Squeeze the shutter button rather than pressing down firmly. Try to use just the tip of your finger to press down to avoid camera shake.

For extra stability, you can also brace yourself against a doorjamb or wall. You can even position the camera on a chair or tabletop to steady it. Monopods are also great supports that allow you to be mobile but give you the needed camera support to work in low and ultra-low light.

■ DON'T SKIMP

When making spontaneous portraits, shoot plenty of images. These moments are fleeting and you'll probably shoot quite a few not-so-great images for every really good one you get.

■ MASTER YOUR CAMERA CONTROLS

The best photojournalists have their camera-handling technique down cold. Focusing, composing, and exposing should be second nature. The more efficient you are at handling your camera, the better your portraits will be.

What started out as a serious little portrait by David Williams turned into a moment of hilarity between photographer and subject. David likes to ask children questions and then answer their questions with questions, which eventually produces a response like this.

26. CANDID SHOTS: TIPS FOR SUCCESS

This is the Dennis Orchard photo described below.

Many professional photographers specialize in images that are either partially or completely spontaneous. Below, four of the best offer their tips for success. Note that the net result of the techniques described by these photographers is the release and capturing of spontaneous expressions.

■ TIM KELLY

Spontaneous portraits sometimes happen even while working on planned portraits. Tim Kelly, a modern-day portrait master, says, "Watch your subjects before you capture the image. Sometimes the things they do naturally become great artistic poses." For this reason, Kelly does not warn his clients when he is ready to start a portrait session. "I don't believe in faking the spontaneity of the subject's expression," Kelly says.

■ DENNIS ORCHARD

While the pure photojournalist does not intrude on the scene, it is sometimes necessary to inject a bit of "direction" into the scene. Dennis Orchard, a well known wedding photographer from the U.K., observed a mother embracing her two sons at a wedding. By the time he got up on a chair, the shot had dis-

appeared. He called over to the mom and said, "How about another hug?" Since the emotion was still fresh, she complied and Orchard got the shot.

■ MARCUS BELL

Marcus Bell, an Australian wedding and portrait photographer is gifted at putting people at ease. This minimizes the direction he needs to give them, resulting in more spontaneous portraits. Bell also uses the LCD screen of his digital camera as social and posing prompts, showing his subjects between shots what's going on and offering friendly ways to improve on the pose. According to Marcus, "This builds rapport, trust, and unity as you have their cooperation and enthusiasm."

■ JERRY GHIONIS

Jerry Ghionis, another successful Australian wedding and portrait photographer, does not pose his clients, he "prompts" them. "I prompt them in situations that appear natural," he says. He first chooses the lighting, selects the background and foreground, and then directs his clients into a "rough" pose—a romantic hug, a casual walk, and so forth. The spontaneous moments he gets evolve during the shoot, depending on what suits the personalities he is working with.

A technique Jerry relies on is the "wouldn't it be great" principle. If he thinks, "Wouldn't it be great if the bride cracked up laughing, with her eyes closed and the groom leaning towards her?" Then he will ask for the pose.

Spontaneous portraits like this result when photographer Jerry Ghionis uses the "wouldn't it be great if" principle.

27. CORRECTIVE TECHNIQUES: DIFFUSION

Skin problems are the most frequent physical problem the portrait photographer encounters. Young subjects have generally poor skin—blemishes or pockmarks. Older subjects have wrinkles, age lines, and age spots. In subjects of all ages, the effects of aging, diet, and illness are mirrored in the face.

■ SOFT FOCUS FILTERS

Using a soft focus filter on the camera lens blends the highlights of the image into the shadow areas by diffusing the light rays as they pass through the filter. Soft-focus or diffusion filters come in degrees of softness and are often sold in sets with varying degrees of diffusion. Using such a filter minimizes facial defects and can instantly take years off an elderly subject. Softer images are often more flattering than portraits in which every facial detail is visible. Soft-focus images have also come to connote a romantic mood.

Selective focus done in Photoshop is a near foolproof technique accomplished by creating a background copy layer, diffusing it and then using the eraser tool to erase sharpness back into the image. Areas like the eyebrows, eyes, lips, bridge of the nose, hairline, teeth and chin are all erased in varying degrees so that these areas look sharp. The remaining areas of the face and neck are left soft to create the illusion of flawless skin. Photograph by David Williams.

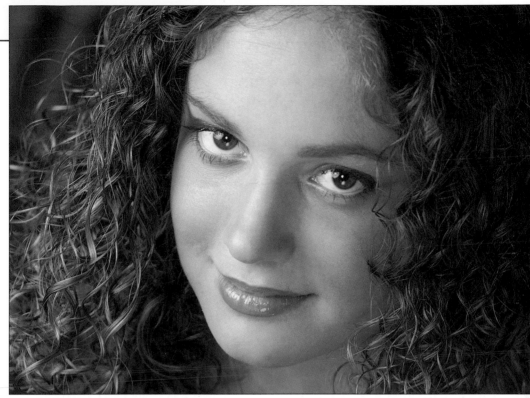

Brian King shoots high school seniors and in order to produce salable orders, some retouching must be done, but he keeps it on the light side. He cleans up blemishes and smooths the overall skin, but leaves some texture so as to look realistic.

■ DIGITAL RETOUCHING

Perhaps the best way to minimize facial flaws is in Photoshop, using selective diffusion, which allows you to keep crucial areas of the face sharp—the eyes, lips, nose, and eyebrows—while softening the problem areas of the face. The viewer is fooled by seeing important parts of the face in focus, making the technique foolproof. For how to do this, see lesson 33.

■ A LITTLE GOES A LONG WAY

Regardless of how you diffuse the image, you will want to be judicious about the amount of softness you give your subject. Men do not want to be photographed too softly, as it may appear effeminate to them. Women with lovely skin will not want to be photographed too softly either, as their good skin is a personal asset they want to show off. In these cases, you may want to use a moderate amount of softness just to blend the skin a little.

28. CORRECTIVE TECHNIQUES: WEIGHT ISSUES

■ OVERWEIGHT SUBJECTS

Have an overweight subject dress in dark clothing, which will make him or her appear ten to fifteen pounds slimmer. Use a pose that has the subject turned at a 45-degree angle to the camera. Never photograph a larger person head-on—unless you are trying to accentuate their size.

Using low-key lighting (producing greate contrast between highlights and shadows) will also help make your subject look thinner, as will using a dark-colored background and trying to merge the tone of the background with that of the subject's clothes.

Standing poses are more flattering. Seated, excess weight accumulates around the waistline. Applying a dark vignette (see lesson 41) at the bottom of the portrait is another trick to minimize the appearance of extra weight.

If the person has excess skin under their chin, raise the camera so that area is less prominent. Tilting the chin upward will also help to stretch out the area.

LEFT—Models and kids can be photographed head on because they are usually thin. In this fashion shot by Anthony Cava, the model is turned toward the camera with no shoulder turn to better show off the garment. RIGHT—Dark clothing is not always used to disguise unwanted pounds. It is often a stylish choice of outfits for a family portrait. Still, one of the benefits of dark clothing and dark backgrounds is that it creates desirable tonal mergers that end up slenderizing the subjects. Photograph by Frank Frost.

Notice that in this charming portrait, the kids are all photographed head on but most of the adults are turned toward the middle, a slenderizing pose. Photo by David Worthington.

■ UNDERWEIGHT SUBJECTS

A thin person is much easier to photograph than an overweight person. Have the person wear light-colored clothing and use high-key lighting (producing lighter shadows) with a light-colored background. When posing a thin person, have him or her face the camera more to provide more width. A seven-eighths angle is ideal for people on the thin side.

If the person is extremely thin, do not allow him or her to wear sleeveless shirts or blouses. For a man, a light-colored sports coat will help fill him out; for a woman, fluffy dresses or blouses will disguise thin arms.

■ FACES

For a thin face, use broad lighting (see lesson 17). Since the more visible side of the face is highlighted, it will appear wider. To slim a wide face, pose the person in a three-quarters view, and use short lighting so that most of the face is in shadow. The general rule is the broader the person's face, the more of it should be kept in shadow; the more narrow the face, the more of it should be highlighted—the basic differences between broad and short lighting.

29. CORRECTIVE TECHNIQUES: EYES, GLASSES

■ EYEGLASSES

The absolute best way to photograph eyeglasses is to use blanks (frames without lenses), obtained from the subject's optometrist. If the portrait session is planned in advance, arrangements can usually be made for a loaner set. If blanks are not available, have the person slide his glasses down on his or her nose slightly. This changes the angle of the glass and helps to eliminate unwanted reflections.

When photographing a subject wearing eyeglasses, the main light source should be soft so that the frames do not cast a shadow that darkens the eyes. Again, look for reflections of the light source on the glass and refine the subject's position to reduce or eliminate them if possible.

When your subject is wearing thick glasses, it is not unusual for the eyes to be darker than the rest of the face. This is because the thickness of the glass reduces the light being transmitted. If this happens, there is nothing you can do about it during the session, but the area can be retouched digitally to restore the same tone as in the rest of the face.

If your subject wears "photo-gray" or any other type of self-adjusting lenses, have him keep his glasses in his pocket until you are ready to shoot. This will keep the lenses from darkening prematurely. Of course, once the light strikes them they will darken, so you may want to encourage your subject to remove the glasses.

Glare on glasses can also be eliminated after the shoot using image-editing software.

Ellie Vayo had her subject shift her weight forward so that she is seated on the edge of the step, thus making her thighs more shapely and slimming her waist and legs. She also had her subject extend her right elbow to create a space between her arm and her body, slimming her waist.

Tim Schooler often minimizes ears in lighting or in Photoshop. This helps keep the viewers' attention on the face.

■ EYES

One Eye Smaller than the Other. Most people have one eye that is smaller than the other. This should be one of the first things you observe about your subject. If you want both eyes to look the same size in the portrait, pose the subject in a seven-eighths to three-quarters view, and seat the person so that the smaller eye is closest to the camera. Because objects farther from the camera look smaller, and nearer objects look larger, both eyes should then appear to be about the same size.

Deep-Set Eyes and Protruding Eyes. To correct deep-set eyes, look for a soft main light source that is relatively low in relation to the subject's face. This will fill the eye sockets with light. Raising the chin will also help diminish the look of deep-set eyes. To correct protruding eyes, look for a higher main light source and have the person look downward so that more of the eyelid is showing.

30. CORRECTIVE TECHNIQUES: EARS, NOSES

WHAT'S THE PROBLEM?

Here's a problem you may not have thought of: what if the person is proud of the trait you consider a difficulty? Or what should you do when you encounter more than one problem?

The first question is best settled in a brief conversation with your subject. You can comment on his or her features by saying something like, "You have large eyes, and the line of your nose is quite elegant." If the person is at all self-conscious about either one of these traits, he or she will usually say something like, "Oh, my nose is too long, I wish I could change it." Then you will know that the person is unhappy with his nose, but happy with his eyes, and you'll know how to proceed.

The second question is a little more difficult. It takes experience before you can discern which of the problems is the more serious one, and most in need of correction. Generally, by handholding the camera and trying a higher or lower camera angle you can see how the physical characteristics are altered. By experimenting with various lighting, poses, and camera angles, you should be able to come up with the best posing strategy.

More than good lighting, posing, and composition techniques, the successful portrait photographer knows how to deal with the irregularities of the human face. All of the great portrait photographers know that their success lies in being able to make ordinary people look absolutely extraordinary.

■ LARGE EARS

To scale down large ears, the best thing to do is to hide the far ear by placing the person in a three-quarters view, making sure that the far ear is out of view or in shadow. If the subject's ears are very large, examine the person in a profile pose. A profile pose will totally eliminate the problem.

■ LONG NOSES AND PUG NOSES

To reduce the appearance of a long nose, lower the camera and tilt the chin upward slightly. Lower the key light so that, if you have to shoot from much below nose height, there are no deep shadows under the nose. You should use a frontal pose, either a full-face or seven-eighths view, to disguise the length of your subject's nose. With long noses and big ears, longer focal lengths will help compress these features.

For a pug nose or short nose, raise the camera height to give a longer line to the nose. Have the subject look downward slightly and try to place a specular white highlight along the ridge of the nose. The highlight tends to lengthen a short nose.

RIGHT—Robert Love has used broad lighting to enhance his subject's features. The high main light position not only produces an elegant, 1920s-style lighting, but it places a long, elegant highlight along the bridge of her nose. BELOW— Robert Love is expert at posing his subjects, optimizing many different features in the same pose. In this image, he had his subject sit on the edge of the stream bank and point her toes on the near leg to shape calf. Notice how he had her curl her left leg inside the ankle of the right leg for a very feminine pose. He used a soft focus filter and a high ISO to create a grainy, idyllic image.

31. CORRECTIVE TECHNIQUES: CHINS, NECKS

■ LONG NECKS AND SHORT NECKS

While a long neck can be considered sophisticated, it can also appear unnatural—especially in a head-and-shoulders portrait. By raising the camera height, lowering the chin, keeping the neck partially in shadow, and pulling up the shirt or coat-collar, you will shorten an overly long neck. If you see the subject's neck as graceful and elegant, back up and make a three-quarter- or full-length portrait and emphasize the graceful line of the neck in the composition.

For short or stubby necks, make sure the neck is not is shadow. Lowering the camera height and suggesting a V-neck collar will also lengthen the appearance of a short neck.

■ LONG CHINS AND STUBBY CHINS

Choose a higher camera angle and turn the face to the side to correct a long chin. For a stubby chin, use a lower camera angle and photograph the person in a frontal pose.

LEFT—Joe Photo created a stylish pose for this bride. The strong side-lighting reveals her slender figure and long neck. FACING PAGE—Bruno Mayor capitalized on the wonderful light between two buildings by having his bride look up so that the soft overhead light sculpted her upturned face.

MOUTHS

To reduce an overly wide mouth, photograph the person in three-quarters view and with no smile. For a narrow or small mouth, photograph the person in a more frontal pose and have him or her smile broadly.

■ VERY DARK SKIN TONES

Unusually dark skin tones must be compensated for in exposure if you are to obtain a full tonal range in the portrait. For the darkest skin tones, open up a full f-stop over the indicated exposure reading. For moderately dark subjects, like deeply suntanned people, open up one-half stop over the indicated exposure.

■ OILY SKIN

Excessively oily skin looks shiny in a portrait. If you combine oily skin with sharp, undiffused lighting, the effect will be unappealing. When you know

LEFT AND FACING PAGE—Tim Schooler is an expert at photographing faces. In both examples shown here, available light is reflected back onto the faces using a silver reflector. This type of reflector not only adds volume of light but specular highlights (tiny pure white highlights within the main highlight). Tim photographs in RAW mode and then processes the images in Phase One Capture One software, choosing to emulate film, with a higher than normal contrast setting. This way he has less retouching to do in Photoshop and leaves the skin looking fresh and beautiful.

you'll be taking posed portraits, you may want to keep a powder puff and face powder on hand to pat down oily areas. The areas to watch are the frontal planes of the face—the center of the forehead and chin, and the cheekbones.

■ DRY SKIN

Excessively dry skin looks dull and lifeless in a portrait. To give dry skin dimension, use an undiffused main light source. If the skin still looks dull and without texture, use a little lotion on the person's face to create small specular highlights in the skin. Don't overdo it with the lotion, though, or you will have the reverse problem—oily skin.

■ SKIN DEFECTS

Facial imperfections like scars and discoloration are best disguised by placing them in shadow. Many of these issues can now also be addressed using digital retouching.

33. RETOUCHING: SELECTIVE FOCUS

■ THE BASICS

Providing a complete course in portrait retouching is, obviously, beyond the scope of this book. However, there are several basic techniques you should be aware of—techniques you'll use repeatedly to fine-tune your images and create the most flattering version of each portrait.

While there are many excellent image-editing programs on the market, the industry standard is Adobe Photoshop. Therefore, that's the program we'll use in the lessons that follow. If you prefer to use another piece of software, you'll find that the basic steps will probably still work, but the tool names and menu entries will likely be different.

■ SELECTIVE FOCUS

To begin, duplicate the background layer. Blur the background copy layer using the Gaussian blur filter (Filter>Blur>Gaussian Blur) at a pixel radius of 10 or less. From there, you can employ one of two different methods.

Method one entails using the eraser tool with a soft-edged, medium-sized brush at an opacity of 100 percent to reveal the hidden original background layer, restoring sharpness in the areas where you want it.

Method two involves using the lasso tool. Holding down the Shift key allows you to make multiple selections. Select the areas around the eyes and eyebrows, the hairline, the tip of the nose, the lips and teeth, the front edge of the ears, any jewelry that shows and other surface details that should be sharp. Next, feather the selection, blurring its edges so that the layers will blend seamlessly. To do this, go to Select>Feather and set the feather radius at up to 25 pixels. Next, hide the selections (Command + H) so that the selection indicator disappears. Then, hit Delete and the background layer will show through. If you missed something, hit deselect (Command + D) and select the new area (or areas). Once these are feathered, hit Delete.

DUPLICATE THE BACKGROUND LAYER

It's a good practice to duplicate the background layer of your image before beginning your retouching work. In Photoshop, you can do this by dragging the background layer onto the New Layer icon at the bottom of the Layers palette. Duplicating the background layer allows you to selectively combine your retouching with the underlying original image and makes it easy to revert to the original image if necessary—just delete the duplicated layer.

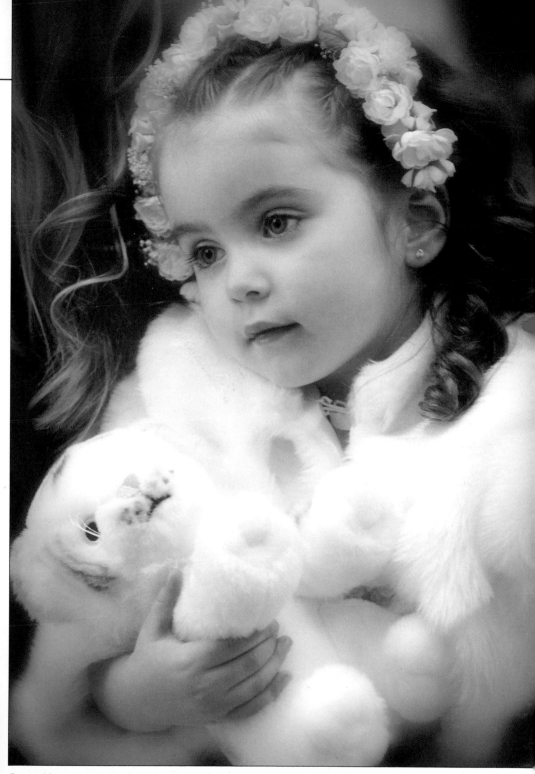

Bruno Mayor created multiple levels of softness throughout this lovely image to make it dreamlike and idyllic. Working in Photoshop layers, you can create selective diffusion in different areas of the image without ever affecting the original image. Always "save as" to preserve the original and save the altered file with a new name.

34. RETOUCHING: REMOVING BLEMISHES

To remove small blemishes, dust spots, marks, or wrinkles, select the healing brush. When this tool is active, an options bar will appear at the top of the screen. Select the normal mode and choose "sampled" as the source setting.

Next, select a soft-edged brush that is slightly larger than the area you are going to repair. Press Opt/Alt and click on a nearby area with the same tone and texture as the area you wish to fix.

Then, click on the blemish and the sample will replace it. If it doesn't work, undo the operation (Command + Z), sample another area and try again.

CONTOURING WITH THE LIQUIFY FILTER

Photoshop has a fascinating suite of tools under the filters menu. The liquify function is a very useful one, as it allows you to bend and twist features either subtly or dramatically. When you activate the liquify function (Filter>Liquify), a full-screen dialog box will appear with your image in the center. To the left of the image are a set of tools that let you warp, pucker, or bloat an area simply by clicking and dragging. There is even a tool that freezes an area, protecting it from the action of the tool. When you want to unprotect the area, simply use the thaw tool. To the right of the image, you'll find settings for the brush size and pressure.

Using this tool, it is a simple matter to give your subject a tummy tuck, or take off fifteen pounds with a few well placed clicks on the hips and/or waistline. It is outrageous how simple this tool is to use, and the effects are seamless if done subtly. (If you notice that you have overdone it, however, there is even a reconstruct tool that undoes the effect gradually—like watching a movie in reverse.)

Be careful not to eliminate elements of his or her appearance that the subject actually likes—these "flaws" are, after all, part of what makes every person unique. When this happens, you have gone too far. It is always better to approach this type of reconstructive retouching with a little feedback from your subject and a lot of subtlety.

The liquify function is like a separate application by itself. It will take some practice and experimentation to perfect the techniques. However, for the most commonly needed refinements of subject features, it is a snap.

The healing brush differs from the clone tool in that the healing brush automatically blends the sampled tonality with the area surrounding the blemish or mark. However, the clone tool can be very useful for concealing blemishes in areas where you find that the healing brush has problems accurately blending the tonalities from the surrounding areas.

Jerry D utilized many Photoshop tricks to get this image right. He selectively softened it, vignetted the image with a diffused colored vignette and then the magic started. The bride asked him to make her slimmer, which he did by moving her arm closer to her body to mask the line of her torso. You cannot tell where the retouching was done and apparently the bride was ecstatic over Jerry's magic.

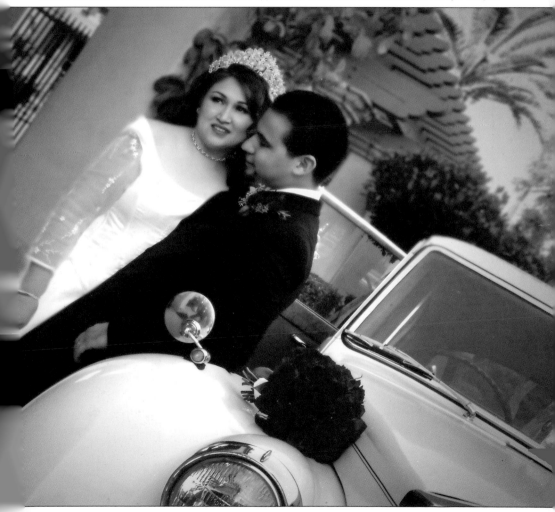

35. RETOUCHING: SHININESS, WRINKLES

To reduce the appearance of wrinkles and shiny areas, select the clone tool and set its opacity to 25 percent. The mode should be set to normal and the brush should be soft-edged. Like the healing brush, sample an unblemished area by hitting Opt/Alt and clicking on the area you want to sample.

As you use the tool, keep an eye on the cross-hair symbol that appears to show you the sampled area you are about to apply with your next click of the tool. If this area begins to move into a zone that is not the right color or texture, hit Opt/Alt and resample the desired area.

The clone tool is very forgiving and can be applied numerous times in succession to restore a relatively large area. As you work, you will find that the more you apply the cloned area the lighter the wrinkle becomes or the darker the shiny area becomes. Be sure to zoom out and check to make sure you haven't overdone it. This is one reason why it is always safer to work on a copy of the background layer instead of the background layer itself.

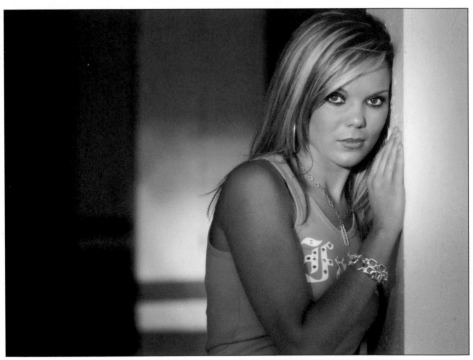

Situations such as late afternoon light and flash fill will often create shiny skin, sometimes because the sun is warm causing mild perspiration; sometimes because the flash illuminates a flat plane of the face, making it look shiny. Methods, such as those described above, are great for reducing shininess. Photograph by Bruno Mayor.

Sometimes adding grain (Filter>Texture>Grain) or noise (Filter>Noise>Add Noise) can create a "fine art" kind of texture to the image that looks purely photographic in nature. Its benefit is that the grain or noise often hides complex retouching that may need to be done. In this case, the image uses textural grain for effect. Photograph by Norman Phillips.

When reducing shine, don't remove the highlight entirely, just subdue it. The same goes for most wrinkles. For a natural look, they should be significantly subdued, but not completely eliminated.

36. RETOUCHING: TEETH, EYES

■ TEETH AND EYES

By quickly cleaning up eyes and teeth, you can put real snap back into the image. To do this, use the dodge tool at an exposure of 25 percent. Since the

It is important to retouch teeth and eyes realistically. The whites of the eyes without a trace of blood vessels looks unnatural; while teeth that are white but not blindingly bright are appropriate and natural. Photograph by Jeff Smith.

A clean crisp smile denotes a winning personality. With teenage kids, it's not unusual to see brilliantly white teeth. Also, you may often see teeth that have been bleached to an almost pure white. Photograph by Jeff Smith

Eyeglasses are fairly easy to clean up using the Clone tool and Healing brush. The trick is to use a small, soft-edged brush and lowered opacity. Photograph by David Bentley.

whites of the eyes and teeth are only in the highlight range, set the range to highlights in the options bar.

For the eyes, use a small soft-edged brush and just work the whites of the eyes—but be careful not to overdo it. For teeth, select a brush that is the size of the largest teeth and make one pass. Voilà! That should do it.

For really yellow teeth, first make a selection using the lasso tool. This doesn't have to be extremely precise. Next, go to Image>Adjustments>Selective Color. Select "neutrals" and reduce the yellow. Make sure that the method setting at the bottom of the dialog box is set to absolute, which gives a more definitive result in smaller increments. Remove yellow in small increments (one or two points at a time) and gauge the preview. You will instantly see the teeth whiten. Surrounding areas of pink lips and skin tone will be unaffected because they are a different color.

■ GLARE ON GLASSES

Glare on glasses is a problem that's easily remedied. Enlarge the eyeglasses, one lens at a time. With the clone tool, select a small, soft brush and set its opacity to about 50 percent. The reduced opacity will keep the glass looking like glass. Sample an adjacent area (Option/Alt + click) and start to cover over the highlight.

37. PRINT FINISHING: CONTRAST

Many times a digital image is created lacking contrast—which is a good thing, because it preserves highlight and shadow detail in the original image. With too little contrast, however, the image will be unsuitable for printing.

Some scenes may have varying amounts of contrast within them. For example, the background in the distance is lower in overall contrast than the grass in the foreground. The lighting on the faces is slightly lower in contrast than the clothing. A good range of tones from highlights to shadows is visible throughout. Photograph by Rick Ferro.

To produce an image file that will not only look good on screen, but print well also, you must have detail in the shadows and highlights, as well as a good snappy contrast as does this image by Jeff Smith.

Overall contrast can be adjusted using the highlight and shadow sliders in the levels (Image>Adjustments>Levels). In the Levels dialog box, by adjusting the shadow slider (the black triangle) to the right, you punch up the blacks. By adjusting the highlight slider (the white triangle) to the left, you clean up the whites.

The trick is to preserve shadow and highlight detail throughout. To review this, look at the Luminosity channel of the image histogram (Window> Histogram). Move your cursor over the black point and white point while keeping an eye on the "level" field in the window below. Basically, a detailed white (for all printers) is around 235–245 (in RGB mode). A detailed black is around 15–35 (in RGB mode), depending on the printer and paper used.

38. PRINT FINISHING: COLOR

For professionals, the curves are considered Photoshop's most precise tool for color-correcting an image. Using the curves is, however, a complicated and subjective process that takes some time to learn.

For less advanced Photoshop users, or when only small and isolated changes are needed, the selective color command (Image>Adjustments>Selective Color) can be extremely useful. This tool does not require you to know in advance which channel (R, G, or B) is the one affecting the color shift. It only requires you to select which color needs adjustment.

In the selective color dialog box, you'll see slider controls for cyan, magenta, yellow, and black. At the bottom of the box, make sure that the method is set to absolute, which gives a more definitive result in smaller increments. At the top of the box, choose the color you want to change by selecting it from the pull-down menu. You can choose to alter the reds, yellows, greens, cyans, blues, magentas, whites, "neutrals," or blacks. Once you've selected the color to change, simply adjust the sliders to modify the selected color in whatever way you like.

The changes you make to the sliders in the dialog box will affect only that color. Note, however, that the changed values will affect every area of that color. Therefore, if you select "blue" to change the color of the sky, it will also change the blue in the subject's eyes and her blue sweater.

Janet Baker Richardson created this wonderful portrait in black & white. In Photoshop, the image was converted to RGB and Selective Color was used to make it a sepia tone. You can see in the Selective Color dialog box that the neutrals were altered by adding magenta and yellow.

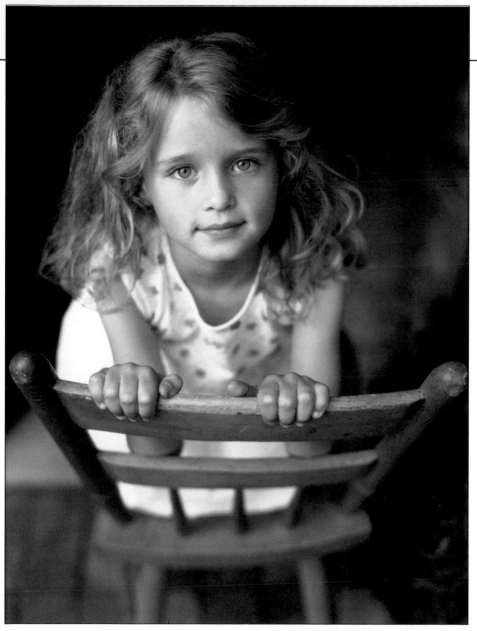

When using the selective color command, most skin tones fall into the range that is considered neutral, so you can color correct the skin tones without affecting the white dress or the brightly colored bridesmaid's gowns, for instance. Skin tones are comprised of varying amounts of magenta and yellow, so these are the sliders that normally need to be adjusted. In outdoor images, however, you will sometimes also pick up excess cyan in the skin tones; this can be eliminated by using the cyan slider.

39. PRINT FINISHING: VIGNETTES

Vignettes can help focus the viewer's attention on the subject's face. Many photographers vignette every image in printing, darkening each corner to draw emphasis to the center of interest in the image.

This particular Photoshop vignetting technique comes from digital artist Deborah Lynn Ferro. To begin, duplicate the background layer. In the layers palette, create a new layer set to the normal mode.

Then, select a color for the vignette by clicking on the foreground color in the main toolbar to bring up the color picker. You can choose any color or sample a color from within the photograph to guarantee a good color match (this is done using the eyedropper tool—click once and the sampled color becomes the foreground color).

Next, use the elliptical marquee tool or the lasso tool to select an area around the subject(s). Inverse the selection (Select>Inverse) and feather it

Tibor Imely created this wonderful family portrait at dusk using the fading twilight and low power fill flash at the camera position. He later added a transparent vignette around the family in order to subdue the light colored tones at the edges of the print. The vignette focuses the viewer's attention on the subjects.

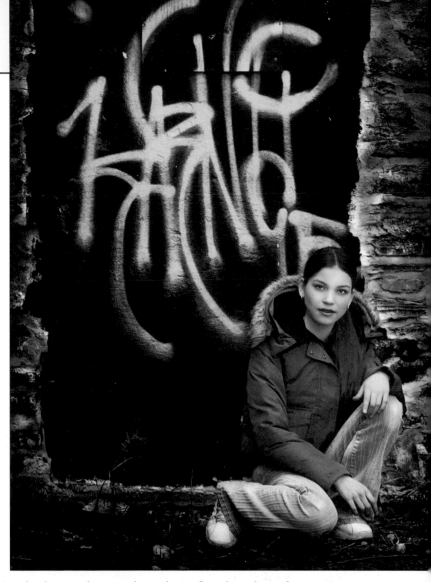

Anthony Cava created a vignette that hugs the border of the print. The vignette subdues the high contrast stonework in the image, which would otherwise detract from the subject.

(Select>Feather)—the larger the number, the softer the edge of your vignette will be. Try feathering to a radius of 75 to 100 pixels to keep the edge of the vignette really soft.

Working on the new layer, fill the feathered selection (Edit>Fill) with the foreground color using a low percentage (like 10 percent). Be sure to select the "preserve transparency" option at the bottom of the fill dialog box.

You can also combine the vignette with various other filters. For example, if you want to remove unwanted details, add a motion blur (Filter>Blur> Motion Blur) to the feathered background. The effect will wash away any unwanted image details and create a beautifully stylized, yet subtle effect.

40. PRINT FINISHING: TONING

With your image in RGB color mode, create a copy of the background layer. Working on that layer, go to Image>Adjustments>Desaturate to create a monotone image. Use the levels or curves to adjust the contrast at this point, if so desired.

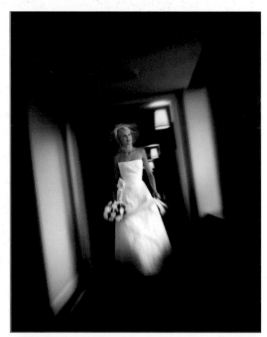

Next go to selective color (Image>Adjustments>Selective Color) and choose "neutrals" from the color menu. Then adjust the magenta and yellow sliders to create a sepia look. Using more magenta than yellow

Here are two examples of toned images from award winning wedding, portrait and landscape photographer, Marcus Bell. It is important to experiment with the tone that best matches the subject matter—for instance the "cool, blue bride" pictured here.

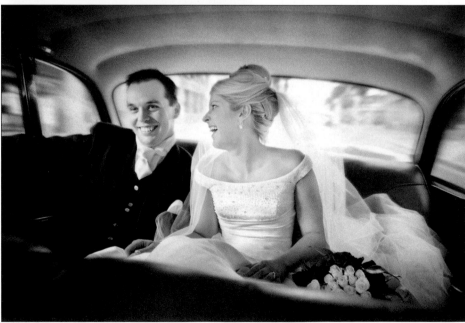

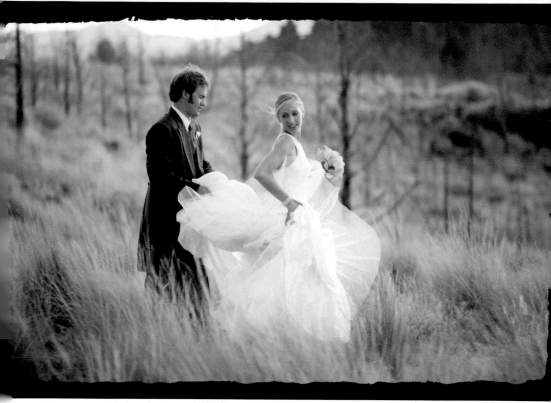

Kevin Kubota created this striking monotone image where the only color is that of the bride's bouquet. Thoughtful use of this technique heightens its effectiveness.

will give you a truer sepia tone. More yellow than magenta will give a brown or selenium image tone. The entire range of warm toners is available using these two controls.

If you want to create a cool-toned image, you can simply add cyan or reduce yellow (or both). Again, a full range of cool tones is available in almost infinite variety.

MIXING COLOR AND BLACK & WHITE

A popular effect is to add bits of color to a monochrome image. This technique is done by duplicating the background layer of a color image, then desaturating it (Image> Adjustments>Desaturate). Working on the duplicate layer, adjust brightness and contrast to your liking, then select the eraser tool. Choose a medium-sized soft brush and set the opacity of the eraser to 100 percent. Then, start to erase the areas you want to be in color (allowing the underlying color layer to show through the black & white desaturated layer in the erased areas).

41. PRINT FINISHING: SHARPENING

As most Photoshop experts will tell you, sharpening is the final step in working an image and one of the most common flaws in an image is over-sharpening. Photoshop's sharpen filters are designed to focus blurry or softened images by increasing the contrast of adjacent pixels. This makes it easy to over-sharpen an image and compress detail out of an area or the entire image.

The most flexible of Photoshop's sharpening tools is the unsharp mask filter, but it needs to be used carefully. The best method is to convert the image to the Lab Color mode (Image>Mode>Lab Color). In the channels palette, click on the lightness channel to deselect the A and B channels (the image will look black & white). Use the unsharp mask filter to sharpen only that channel, then restore the A and B channels by clicking on the composite Lab channel at the top of the channels menu. Go to Image>Mode to convert the image back the desired mode, and you will be amazed at the results.

Another way to effectively use the unsharp mask filter is to apply it to just one channel in an RGB image. To see the difference this makes, duplicate your image (Image>Duplicate) and place the two identical windows side by side on your screen. On one image, apply the unsharp mask to the image without selecting a channel. In the unsharp mask dialog box, select the following settings: amount—80 percent; radius—1.2 pixels; threshold—0 levels. On the second image, go to the channels palette and look at each channel individually. Select the channel with the most midtones (usually the green channel, but not always) and apply the unsharp mask filter using the same settings. Then, turn the other two channels back on. Enlarge a key area, like the face, of both images to exactly the same magnification—say 200 percent. At this level of sharpening, you will probably see artifacts in the image in which all three layers were sharpened simultaneously. In the image where only the green channel was sharpened, you will see a much finer rendition.

Digital images are by nature sharper than film images. The level of sharpness one can achieve from a carefully exposed and focused digital file is simply amazing. It is a good idea to check sharpness in every image, but you may not want to sharpen each image. Over-sharpening produces an edge around detailed objects that looks artificial. In this great portrait by Frank Frost, the image is extremely sharp, but not overly sharpened.

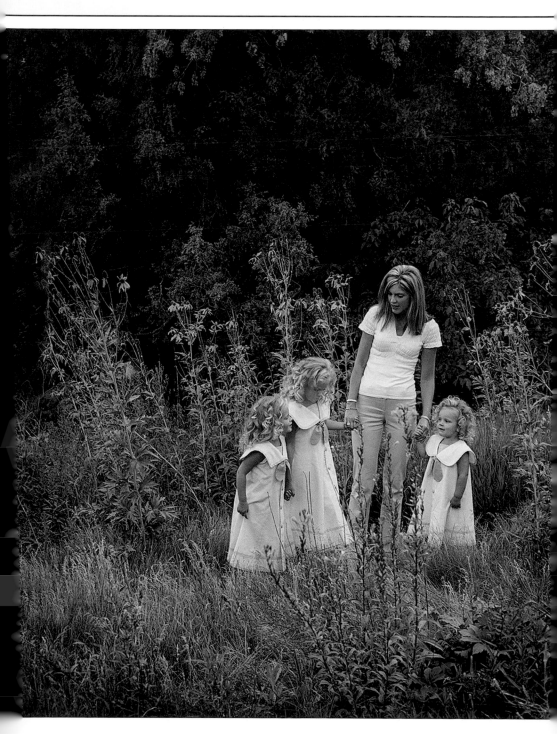

CONCLUSION

There is no doubt that digital technology has influenced the world of portraiture. Digital offers the portrait photographer flexibility, creative control, and the ability to instantly preview images—meaning that if you missed the shot, you can redo it right then and there. The daunting task of traditional retouching has also been all but eliminated by Adobe Photoshop. Another benefit of digital is its archival permanence. A digital image is stable over time and every copy is a perfect copy. Multiple copies stored on stable media assure survivability and endurance over time.

Having finished reading this book—and, hopefully, having tried out many of the techniques—you should have a good understanding of posing basics, lighting techniques, and good all-around portrait techniques. This will be your baseline for acheiving the more common portrait styles with a high level of expertise.

As you expand your portrait skills, you may also want to pick up other Digital Quick Guides™, which cover a variety of additional topics of interest to portrait photographers—from posing and composition, to more comprehensive digital retouching and enhancement techniques.

CONTRIBUTORS

A very special thanks to all of the photographers who graciously contributed images to this book. Without their help, it would not have been possible.

Janet Baker Richardson
www.jbrphoto.com

Becker
www.thebecker.com

Marcus Bell
www.studioimpressions.com.au

David Bentley
www.bentleystudio.com

Stacy Bratton
www.stacybratton.com

Anthony Cava
www.photoluxstudio.com

Frank Cava
www.photoluxstudio.com

Tony Corbell
www.corbellproductions.com

Jerry D
www.jerrydphoto.com

Terry Deglau
www.terrydeglau.com

Fuzzy Duenkel
www.duenkel.com

Scott Eklund
www.scotteklundphotography.com

Rick Ferro
www.rickferro.com

Deborah Lynn Ferro
www.rickferro.com

Frank Frost
www.frankfrost.com

Jennifer George Walker`
jgwphoto@san.rr.com

Jerry Ghionis
www.xsight.com.au

Dale Hansen
dalehandsome@yahoo.com

Judy Host
www.judyhost.com

Tibor Imely
www.imelyphoto.com

Kevin Jairaj
www.kjimages.com

Tim Kelly
www.timkellyportraits.com

Brian King
www.hrimaging.com

Kevin Kubota
www.kkphoto-design.com

Robert & Suzanne Love
lovephoto@aol.com

Heidi Mauracher
http://ppgba.org/html/heidi_s_bio
.html

Bruno Mayor
www.espaceimage.com

Craig Minielly
www.craigsactions.com

Melanie Nashan
www.nashan.com

Dennis Orchard
www.dennisorchard.com

Joe Photo
www.joephoto.com

Norman Phillips
www.normanphillipsoflondon.com

Fran Reisner
www.franreisner.com

Kimarie Richardson
www.fantasystills.com

Tim Schooler
www.timschooler.com

Brian Shindle
bts_jks@msn.com

Jeff Smith
www.jeffsmithphoto.com

Deanna Urs
www.deannaursphotography.com

Ellie Vayo
www.evayo.com

David Williams
www.davidwilliams-heartworks.com

David Worthington
www.daveworthington.com

GLOSSARY

Aperture, optimum. The aperture that produces the sharpest image. It is usually two stops stopped down from wide open. If lens is an f/2.8, optimum aperture would be f/5.6.

Broad lighting. One of two basic types of portrait lighting in which the key light illuminates the side of the subject's face turned toward the camera.

Catchlight. The specular highlights that appear in the iris or pupil of the subject's eyes reflected from the portrait lights.

Channel. Used extensively in Photoshop, channels are images that use grayscale data to portray image components. Channels are created whenever you open a new image and accessed in the Channels palette. The image's color mode determines the number of color channels created. For example, an RGB image has four default channels: one for each of the red, green, and blue colors plus a composite channel used for editing the image.

Color temperature. The degrees Kelvin of a light source or film sensitivity. Color films are balanced for 5500°K (daylight), or 3200°K (tungsten) or 3400°K (photoflood).

Cross-lighting. Lighting that comes from the side of the subject, skimming facial surfaces to reveal the maximum texture in the skin. Also called side-lighting.

Curves. Changing the shape of the curve in the Curves dialog box alters the tonality and color of an image. Bowing the curve upward lightens an image, and bowing the curve downward darkens it. Steeper sections of the curve represent areas with more contrast; flatter sections represent areas of lower contrast.

Depth of field. The distance that is sharp beyond and in front of the focus point at a given aperture.

Fill light. Secondary light source used to fill in the shadows created by the key light.

Flash fill. Flash technique that uses electronic flash to fill in the shadows created by the main light source.

Full-length portrait. A pose that includes the full figure of the model standing, seated, or reclining.

Gaussian blur. A filter in Photoshop used to blur images by an adjustable amount. This can produce a hazy effect.

Gobo. Light-blocking card positioned between the light source and subject to selectively block light from portions of the scene.

Golden mean. A rule of composition determined by drawing a diagonal line from one corner of the frame to the other, then drawing a second line from either remaining corner so that the diagonal is intersected perpendicularly.

Grayscale. Color model consisting of up to 254 shades of gray plus absolute black and absolute white. Every pixel of a grayscale image displays as a brightness value ranging from 0 (black) to 255 (white).

Head-and-shoulder axis. Imaginary lines running through shoulders (shoulder axis) and down the ridge of the nose (head axis). Head and shoulder axes should never be perpendicular to the line of the lens axis.

High-key lighting. Type of lighting characterized by low lighting ratio and a predominance of light tones.

Histogram. A graph associated with a single image file that indicates the number of pixels that exist for each brightness level. The range of the histogram represents 0-255 from left to right, with 0 indicating "absolute" black and 255 indicating "absolute" white.

Levels. In Photoshop, Levels allows you to correct the tonal range and color balance of an image.

Lighting ratio. The difference in intensity between the highlight side of the face and the shadow side of the face. A 3:1 ratio implies that the highlight side is three times brighter than the shadow side of the face.

Low-key lighting. Type of lighting characterized by a high lighting ratio and strong

scene contrast as well as a predominance of dark tones.

Noise. Noise is made up of luminance (grayscale) noise, which makes an image look grainy, and chroma (color) noise, which is usually visible as colored artifacts in the image. Photographing with a higher ISO can result in images with objectionable noise. Luminance Smoothing reduces grayscale noise, while Color Noise Reduction reduces chroma noise.

Plug-ins. Programs developed by Adobe and by other software developers in conjunction with Adobe Systems to add features to Photoshop. A number of importing, exporting, and special-effects plug-ins come with Photoshop; they are automatically installed in folders inside the Plug-ins folder

Reflector. A white or silver-foil-covered card used to reflect light back into the shadow areas of the subject.

Resolution. The resolution of an image is determined by the number of pixels per inch. Higher-resolution images can reproduce more detail and subtler color transitions than lower-resolution images because of the density of the pixels.

RGB (Red, Green and Blue). Computers and other digital devices handle color information as shades of red, green and blue. A 24-bit digital camera, for example, will have 8 bits per channel in red, green and blue, resulting in 256 shades of color per channel.

Rule of thirds. Format for composition that divides the image area into thirds, horizontally and vertically. The intersection of two lines is a dynamic point where the subject should be placed for the most visual impact.

Scrim. A panel used to diffuse sunlight. Scrims can be mounted in panels and set in windows, used on stands, or they can be suspended in front of a light source to diffuse the light.

⅞ view. Facial pose that shows approximately ⅞ of the face. Almost a full-face view as seen from the camera.

Sharpening. In Photoshop, filters that increase apparent sharpness by increasing the contrast of adjacent pixels within an image.

Short lighting. One of two basic types of portrait lighting in which the key light illuminates the side of the face turned away from the camera.

Specular highlights. Sharp, dense image points on the negative. Specular highlights are very small and usually appear on pores in the skin.

¾-length pose. Pose that includes all but the lower portion of the subject's anatomy. Can be from above knees and up, or below knees and up.

¾ view. Facial pose that allows the camera to see ¾ of the facial area. Subject's face usually turned 45° away from the lens so that the far ear disappears from camera view.

Unsharp mask. A sharpening tool in Adobe Photoshop that is usually the last step in preparing an image for printing.

Vignette. A semicircular, soft-edged border around the main subject. Vignettes can be either light or dark in tone and can be included at the time of shooting, or added later in printing or in Photoshop.

White Balance. The camera's ability to correct color and tint when shooting under different lighting conditions including daylight, indoor and fluorescent lighting.

Wrap-around lighting. Soft type of light that wraps around subject producing a low lighting ratio and open, well-illuminated highlight areas.

INDEX

PORTRAIT PHOTOGRAPHER'S HANDBOOK, 2nd Ed.

Bill Hurter

Bill Hurter, editor of *Rangefinder* magazine, presents a step-by-step guide to professional-quality portraiture. The reader-friendly text easily leads you through all phases of portrait photography, while images from the top professionals in the industry provide ample inspiration. This book will be an asset to experienced photographers and beginners alike. $29.95 list, 8½x11, 128p, 175 color photos, order no. 1708.

THE PORTRAIT PHOTOGRAPHER'S
GUIDE TO POSING

Bill Hurter

Posing can make or break an image. Now you can get the posing tips and techniques that have propelled the finest portrait photographers in the industry to the top. Includes techniques for location and studio images, group portraits, formal and casual images, and much more! $29.95 list, 8½x11, 128p, 200 color photos, index, order no. 1779.

THE BEST OF PHOTOGRAPHIC LIGHTING

Bill Hurter

A well-developed knowledge of how lighting works and how best to exploit it accounts, more than any other factor, for the consistent ability to produce fine photography. In this book, *Rangefinder* editor Bill Hurter shows you how the industry's most acclaimed professionals design lighting that makes the most of every scene or subject. Packed with practical tips and truly dazzling images, this book will both inform and inspire! $34.95 list, 8½x11, 128p, 150 color photos, index, order no. 1808.

OUTDOOR AND LOCATION
PORTRAIT PHOTOGRAPHY, 2nd Ed.

Jeff Smith

With its ever-changing light conditions, outdoor portrait photography can be challenging—but it can also be incredibly beautiful. Learn to work with natural light, select locations, and make all of your subjects look their very best. This book is packed with illustrations and step-by-step discussions to help you achieve professional results! $29.95 list, 8½x11, 128p, 80 color photos, index, order no. 1632.

BEGINNER'S GUIDE TO
ADOBE® PHOTOSHOP® ELEMENTS®
Michelle Perkins

This easy-to-follow book is the perfect introduction to one of the most popular image-editing programs on the market. Short, two-page lessons make it quick and easy to improve virtually every aspect of your images. You'll learn to: correct color and exposure; add beautiful artistic effects; remove common distractions like red-eye and blemishes; combine images for creative effects; and much more. $29.95 list, 8½x11, 128p, 300 color images, index, order no. 1790.

BEGINNER'S GUIDE TO
PHOTOGRAPHIC LIGHTING
Don Marr

Learn how to create high-impact photographs of any subject (portraits, still lifes, architectural images, and more) with Marr's simple techniques. From edgy and dynamic to subdued and natural, this book will show you how to get the myriad effects you're after—and you won't need a lot of complicated equipment to create professional-looking results! $29.95 list, 8½x11, 128p, 150 color photos, index, order no. 1785.

THE PRACTICAL GUIDE TO DIGITAL IMAGING
Michelle Perkins

This book takes the mystery (and intimidation!) out of digital imaging. Short, simple lessons make it easy to master all the terms and techniques. Includes: making smart choices when selecting a digital camera; techniques for shooting digital photographs; step-by-step instructions for refining your images; and creative ideas for outputting your digital photos. Techniques are also included for digitizing film images, refining (or restoring) them, and making great prints. $29.95 list, 8½x11, 128p, 150 color images, index, order no. 1799.